Growing Up in
LONG BEACH

BOOMER MEMORIES FROM AUTOETTES TO LOS ALTOS DRIVE-IN

TIM GROBATY

THE
History
PRESS

Published by The History Press
Charleston, SC 29403
www.historypress.net

First published 2013

Manufactured in the United States

ISBN 978.1.62619.358.1

Library of Congress Cataloging-in-Publication Data

Grobaty, Tim.
Growing up in Long Beach : boomer memories from Autoettes to Los Altos Drive-In /
Tim Grobaty.
pages cm
Includes index.
ISBN 978-1-62619-358-1
1. Long Beach (Calif.)--History--20th century. 2. Long Beach (Calif.)--Social life and
customs. I. Title.
F869.L7G75 2013
979.4'93--dc23
2013043203

Contents

CONTENTS

Preface

At least this is how I recall it. Someone once said, and ironically I can't remember who, "Don't trust anyone's nostalgia but your own." Much of what's in this book is my nostalgia, though, happily, it frequently overlaps with the nostalgia of many who shared in the frequent joys of growing up in Long Beach in the 1950s through 1970s.

I grew up in a new home on Vuelta Grande Avenue in Los Altos in the 1960s when the eastern part of the city boomed all at once, with thousands of homes built practically simultaneously in the mid-1950s. Los Altos and Lakewood Plaza were the new suburbs of the city, making a break from the more than half century of dependency on downtown. Built alongside the houses were a new shopping center, scores of churches, a new college and a new freeway.

I've lived in several parts of town—Bixby Terrace, Los Cerritos, Belmont Heights and elsewhere—but the first twenty years and the last twenty-two were on Long Beach's eastern boundary, so much of what you'll find in these pages is from the part of town that boomed so loudly in the mid-century.

Of course, I have memories of other parts of town: Mom getting me all gussied up for an excursion to Buffum's. Grandma taking me shopping uptown for new clothes at Anthony's, Robert's and Grant. The Pike, though I've omitted our memories of that place (if you insist: I rode on the Cyclone Racer once, and I still wake up screaming at night).

Readers of my column have generously shared many of their memories from all around town during the same era, and plenty of those are included

in the book. I'm grateful for their contributions, many of which sparked long-forgotten memories.

Almost the entirety of this book is made up of columns I've written for the *Press-Telegram* over the course of almost thirty years. The memories are readers' and mine; the mistakes are my own.

This book is dedicated to them and to my sister, Debi Toombs, eleven months my senior, who shared the joys of the whole growing-up thing with me and gave me comfort during the less-joyous times.

A word on pronouns: My beloved readers have grown accustomed to my/our usage of the editorial "we." It was never (or at least originally) my intention for "me" to be "we." The simple explanation is that when I began writing a column in the 1980s, it was to have been written by several reporters on a rotating basis under the title "What's Hot!" I wrote the first one and employed the term "we" so the writers could all share one first-person plural personal pronoun. With no one pitching in, I also wrote the second, third, fourth and next twenty years' worth. I still await the cavalry.

The New Libraries

When we were four years old, we moved to a part of town where there were no old people.

It was great. There were so many kids we could platoon our players in on-the-street pickup games of football and baseball. We just assumed, as kids do under whatever circumstances they're in, that the whole world was like this: tract house after tract house. Thousands of them, all built in a matter of months in the rapidly diminishing shadow of World War II, just a decade after V-J Day. All filled virtually overnight with young couples with plans and dreams big enough to fill a three-bedroom, two-bath house built on a foundation that was ready to accommodate a family room, framed with the potential for a second floor, priced to move, affordable for a guy who worked in a shipyard or an airplane factory or an oil field with a wife who could stay home all day taking care of the two children.

We all grew up at once, that initial generation of kids whose folks bought their homes in Long Beach's far east in the neighborhoods of Los Altos and the Plaza, the pre-ZIP postal codes of 08 and 15. Along with us came shops, grocery stores and other businesses, plus parks and—most memorably—libraries, in our case, the Los Altos and El Dorado branches, those warehouses of the imagination where we spent hundreds of hours rummaging through the card catalogues, pacing the aisles looking the shelves up and down like a general inspecting his troops, searching for the perfect story in which to disappear.

To say nothing of the guided literary tours conducted by the legendary Children's Librarian Marie Reidy, who gently assisted countless young

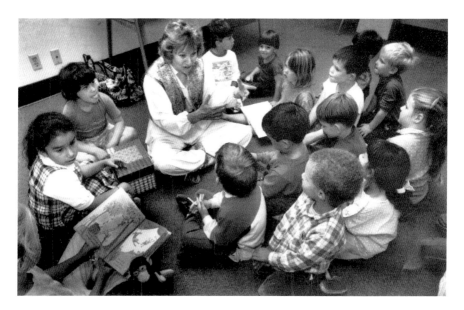

Children's Librarian Marie Reidy kept kids captivated for years at the El Dorado branch library. *Press-Telegram.*

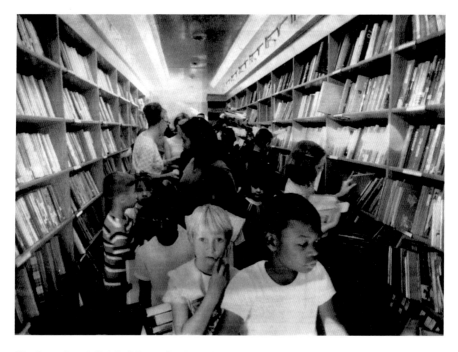

The Long Beach Public Library Bookmobile brought literature to kids near El Dorado Park in 1968 before the El Dorado branch opened in 1970. *Press-Telegram.*

charges in navigating the aisles and who read stories to the children, all captivated, big-eyed and reverentially silent at her feet.

The first branch library to serve the explosively expanding section of Long Beach was the Los Altos branch, which opened in 1957. Almost immediately, children and adults alike, all starved for stories and knowledge, swamped the place. The place was stocked, initially, with 28,890 volumes, but if you showed up late on a Saturday afternoon, you'd likely find several empty shelves, so busy was the little branch at 5614 Britton Drive.

The Los Altos branch became the city's most popular library—it drew more checkouts, even, than the Main Library downtown, which was then the stately Carnegie-funded library in Lincoln Park.

It was apparent that a second branch was needed to serve the Los Altos/Plaza area, and when the El Dorado branch library opened in 1970, the kids and adults once again swarmed over it, quickly snapping up the bulk of its initial stock of twenty-one thousand volumes.

Marie Reidy, to our delight, moved over to ElDo from Los Altos as the children's librarian, a post she held for the next twenty-five years before she retired. Even though we had outgrown the children's section by then (being a big-pants-wearin' ninth grader in 1970), we were still a bit nervous about tackling the serious research stacks, and Reidy helped us make the transition from *The Hardy Boys* to the hard stuff (literarily speaking, of course).

Eastside Memories

For baby boomers suddenly starting to receive their AARP cards in the mail, nostalgia isn't the 1933 earthquake or parks packed with picnickers from Iowa. Rather, it's a sparkling Los Altos Shopping Center built to serve thousands of new homeowners, and an El Dorado Park rising from the old sugar beet fields on the city's far eastside, and the now-retro-camp conveniences of drive-in theaters, drive-in restaurants and drive-thru dairies.

As we wade waist-deep into AARP age ourself, we've been known to hit up readers who grew up in Long Beach during the 1960s for their recollections of those times to supplement, fill in or shore up our own wobbly memories.

So far, it's turned out great. Turns out we didn't make up our glorious past after all!

Reader David Foltz has memories virtually identical to ours. In fact, if we didn't know better, we'd swear he is us. Among his favorite bits of growing up in the '60s are Jerry's Dairy Drive-In "on the west side of Palo Verde Avenue just north of Marita Street, the Plaza Lanes and Plaza movie theater at Spring and Palo Verde, and 49er Days at Cal State Long Beach, with greased pig-catching contests and wanted posters printed with your name on them."

Where our and Foltz's memories totally dovetail, however, are of Annie's Snack Bar, a place we had completely forgotten about, but now that Foltz mentions it, Annie's (which was next to the extant Around the Corner liquor store on Palo Verde and Atherton) was way up on our list of favorite burger shops.

"There were a couple of tables, but we always sat at the counter so we could watch Annie cook," writes Foltz. "I won't swear to it, but my memory is of Annie flipping burgers while a cigarette hung from her lips."

Tim Jacobs might've run into us a time or two, too, riding Sting-Rays, as he recalls doing, through the outdoor aisles of the then-newish Los Altos Shopping Center.

"We'd buy candy at Sav-On and Woolworth and sit around on the planters reading the KHJ Boss Radio Top 30 lists we got at the Musical Jewel Box," Jacobs wrote, swiping a page right out of our own early '70s diary.

Los Altos, in fact, was pretty much the stomping ground for boomers on the eastside. In the '60s, it was the new downtown.

"The Broadway at Los Altos used to be my favorite place to buy a new outfit for dancing on the weekends," writes Patricia Walker. And Art Wild recalls Broadway's "full-course restaurant," which brings back memories of the top-flight clam chowder our Catholic family used to have there on meatless Fridays.

Wild also remembers the "big and popular Thriftimart supermarket, the Helen Grace candy store" and, from the Plaza shopping center, the less-spectacular cousin of the Los Altos Shopping Center, the variety store Quigley's, plus "Scotty's Pet Shop with its grandmotherly, dog-loving proprietor, the Grasshopper home-decorating store with a real-life decorator to hire or consult, the Thrifty Drug Store and its coffee shop."

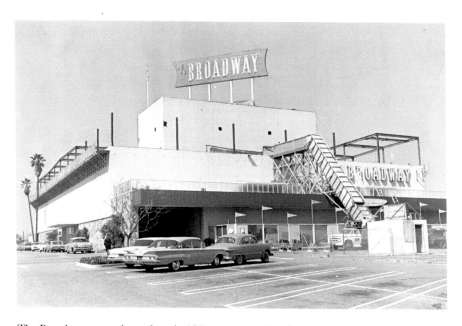

The Broadway store, shown here in 1965, was the pride of the Los Altos Shopping Center and a favorite among eastside shoppers. *Press-Telegram.*

Nearly Lakewood

A reader reminded us that there once was a time when the Plaza, that batch of suburban tracts in Long Beach's far east that includes our own home, was called Lakewood Plaza.

Our memory isn't so elastic that it can stretch back to the early 1950s, when construction companies swarmed over the expanding eastern edge of town to build tract homes east of Woodruff Avenue to Studebaker Road and from just a block or two south of Wardlow Road north to Willow Street. The developers just about exhausted their creative nomenclature coming up with "Lakewood Plaza" (the ultimately erroneous presumption being that Lakewood would quickly annex the territory) because the sections of Lakewood Plaza were called Units 1 through 10.

The homes were deluxe by postwar standards. Although the Lakewood Plaza houses were tract-style, they came with raised foundations, fireplaces, two-car garages and such progressive features as the famed Thermador bathroom heaters and the hyper-utilitarian ConverTable in the kitchen that could be used as a dining nook, breakfast bar, desk or buffet. These things went for around $10,000—not the ConverTable, the whole house.

In 1952, after listening to bigwigs from both Long Beach and Lakewood describe the wonders and riches that would fall upon the Plazanians if they would ally themselves with their respective cities, the residents of Lakewood Plaza decided to throw in their lot with the city of Long Beach.

The major getaway spot during the late '50s and early '60s for Plaza kids especially, though their parents were welcome to tag along, was the

Lakewood Plaza Shopping Center, a sort of oversized strip mall that sprung up on Spring Street on both north and south sides of the street.

While it's still there, it's lost much of its playfulness. There are grocery stores and fitness centers, a Radio Shack and pet stores. Gone, though, are such splendid places to kill time and waste money as the Plaza Bowl and the Plaza Theater, Quigley's five and dime, Scotty's Pet Shop, Norwalk Hardware, Boyes Paint, Edwards Men's Wear, Budd Bakery and even the pre–*Toy Story* Uncle Al's Toy Korral.

One last thing about the Plaza: residents there are used to getting their way. In 1953, when the eastside tract was still in short pants, a reporter noted that the place seemed peaceful enough, "but when trouble strikes or the need arises for promoting the general welfare, the situation is best described by the dictionary definition of a plaza: A fortified place or town."

Among the peeves of the young part of town were the lack of footbridges over the area's ditches and flood controls. Residents wanted mailboxes, bus routes, fire insurance rebates, more ornate streetlight standards and land set aside for park development.

Wrote the *Press-Telegram* reporter in '53:

> *They have a habit of descending en masse on a problem and pummeling the daylights out of the difficulty.*
>
> *These are the weapons of an aroused Plaza: A letter-writing campaign directed at anyone even slightly connected with the cause of the irritation; an elite "housewife brigade"; a verbal offensive by telephone; a prompt publicity push; and two or three alert committees to direct operations.*
>
> *Under this onslaught, opposition to the will of the Plaza has crumbled every time.*

So, let this be a warning to all who would monkey with the Plaza. Do so at your peril. We have ConverTables, and we're not afraid to use them.

The Builder of the New East

A reader from the far east section of Long Beach wrote recently asking how to research houses in Los Altos and the Plaza sections of town.

We didn't give up all our arcane techniques, but we did steer her toward the advertisements in the local newspaper from the 1950s, when most of those homes were built, creating Long Beach's first suburbia. And then, spurred by our own advice, we dove in ourself.

"THEY'RE ALL RUNNING TO LOS ALTOS VILLAGE!" hollered an *Independent-Press-Telegram* ad in 1952. "Join the crowd," the ad exhorted. "Pay less money down and have easier monthly terms in the beautifully planned L.S. Whaley community…TIME IS FLEETING…THEY'RE SELLING FAST… COME OUT EARLY TODAY, AHEAD OF THE CROWD."

And you bet there were crowds. It was as though families were beamed down from space, fully formed. Ones such as ours when our family moved in, with a husband and a wife, a daughter and a son—the dog would come soon—looking for what some have called with varying degrees of irony "the promised land."

Another ad on the same page as the Los Altos hyper-come-on detailed the quality of the homes of Lakewood Plaza, a sprawling series of tracts to the north of Los Altos. A down payment of $450.00, with monthly payments of $60.98, bought a home with such details as:

- two baths with stall shower
- a wall of windows opening onto a paved terrace
- a living room wall of ash or Philippine mahogany

- birch or knotty pine kitchen cabinets
- built-in breakfast nook (equipped with "ConverTables" that folded every which way)
- Waste-King garbage disposal
- Arizona flagstone fireplace and hearth
- full-service porch
- two-car detached or attached garage
- dual wall furnaces
- Zolatone, the new grease- and dirt-repellent paint
- oak floors
- electric Thermador bathroom heaters

The homes ranged from under $10,000 up to $12,000 for more "luxurized" models.

For those people kicking themselves now for not buying a dozen, it helps to bear in mind that in the mid-'50s, about 10 percent of Long Beach families made less than $2,000 a year, and the biggest group, 36 percent, or 50,700 Long Beach families, had annual incomes in the $5,000–$6,999 range.

The tracts came with a promise of a golden near future that included:
- a new nineteen-building, $20 million Long Beach State College
- a lush and lengthy park (tentatively called Los Alamitos Rancho Park, later to be named El Dorado) stretching along the entire eastern boundary of the New East
- a freeway (the Segundo Parkway, later the San Diego, or 405 Freeway) offering convenient transportation out of town and back to the neighborhood
- the Los Altos Shopping Center, a major mercantile spot that would eventually make trips to downtown utterly unnecessary, except for special occasions to that, for us youngsters, faraway and exotic land where all the women wore coats and dresses, and the men wore suits and hats, and we were forced into scratchy woolen pants and garroting neckties for the excursions.

The mastermind of all of Los Altos—virtually the entire New East, as well as the earlier northward expansions of Long Beach—was a young Nebraska transplant named Lloyd S. Whaley who, through his Home Investment Company, began erecting entire neighborhoods in the late 1930s. His projects included Ridgewood Heights, Country Club Manor, Wrigley Terrace, Wrigley Heights and, as he moved into the '50s and eastward, Los

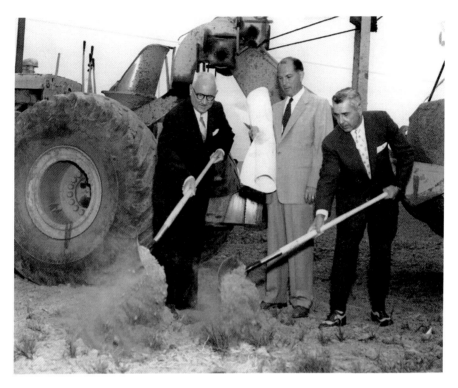

Walker's general manager Clarence Williams watches Walker's president Howard Conrad, *left*, and developer Lloyd Whaley break ground for the Walker's store in Los Altos in July 1964. *Press-Telegram.*

Altos Terrace, University Manor, the tremendously upscale Park Estates (where he built his own home on Bryant Road) and, most sprawling of all, Los Altos Village.

Most of the land was purchased parcel by parcel from Susanna Bixby Bryant, to whom Whaley paid tribute by naming not only the most exclusive street in his most expensive neighborhood for her but also the first post office to serve the New East, the Bryant post office.

Whaley also played a huge role in Long Beach's victory over scores of other towns in landing the newest addition to California's state college system. By gaining the new campus, Whaley ensured the future success of the neighborhoods he built around the college. Long Beach State College ensured home values by bringing a cache of culture and prestige to the entire New East.

Whaley's planning allowed for much more than simply packing homes in close together. He left space for three major parks, including one bearing the

Securing a new campus, Long Beach State College, on the east part of town ensured home values by bringing culture and prestige to the entire New East. *Cal State Long Beach.*

Whaley name, as well as large areas for multiple churches and, of course, the ambitious Los Altos Shopping Center.

The new center opened bit by bit, but by the time it was fully occupied in 1956, it featured in its anchor positions a Walker's (which was soon purchased and renamed by The Broadway), Sav-On Drugs, JCPenney, Woolworth's (with a lunch counter) and, detached and placed off to the northwest, a Thriftimart, whose giant lighted *T* could be seen from miles around.

Other stores running up and down the outdoor center included Gladys Fowler (ladies' apparel), Lerner Shops, Kinney Shoes, Marie's Kiddie Shop, J.C. Wehrman Jewelers, Winstead's Camera Shop, Lonnie's Sporting Goods, the Musical Jewel Box, Ramona Cakes & Pastries, Helen Grace Candies, Horace Green & Sons Hardware, C.H. Baker Shoes and Brownie's Toy Store.

From Slip N' Slides to the Stones

We can't believe we never ran into reader Linda Jensen, whose childhood recollections could double for our own memories of living near the boundary between the Plaza and Los Altos neighborhoods of Long Beach.

Jensen writes that, like us, "I too grew up at Palo Verde Avenue and Stearns Street. I remember the Iowa Pork Shops grocery store, Annie's Snack Shop on Palo Verde and Atherton Street—I ate there every day on the way home from Hill Junior High—Tom's Liquor, and even back when CSULB was still Long Beach State College and we could ride our skateboards and bikes down the college hill (still have some scars from that!)."

Shoot, we somehow managed to forget Tom's Liquor, which was leveled to make way for the Taco Bell that now stands at the northeast corner of Palo Verde and Stearns. If we had every one of the twelve cents we paid for a Hostess Pie (we'd settle for reimbursement for just the lemon ones), we'd be living in a big house on the water now, instead of still in the Plaza. We might be skinnier, too.

Jensen closes with another memory of hers: "I spent a lot of time at Huck Finn's in Belmont Shore," she says.

We didn't spend a ton of time there, but we did see some great acts, especially the balladeer of Belmont Shore back in the 1970s, John Penn.

Reader-writer Adam White grew up in the north end of town, near Artesia and Downey, but some memories go outside the boundaries of neighborhoods—especially if the memorialized thing had wheels. We're talking about the Helms Bakery truck that used to cruise the streets and be

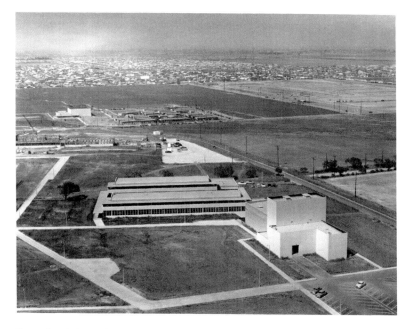

Long Beach State College, as it appeared in 1955, before many of the homes in Los Altos were built. *Press-Telegram archives.*

mobbed by kids and housewives going through the truck's sliding drawers full of baked goods.

White's note begins with the Helms memory ("my favorite was the maple long john, now called a maple bar"), and then he takes off through just about every element of growing up in the '60s: "My brother was a paperboy and I sometimes went around with him to collect so I could eat the cookies the nice people would offer him," writes White.

The litany continues: "The Avon Lady, my mom's Tupperware parties, summer days with Water Wiggles and Slip n' Slides.

"My brothers and I would save our allowances for a couple of weeks and one brother would ride his bike all the way past Pat McCormick Park to Paul's Liquor Store on Lakewood Boulevard and Viking Way to buy a box of 1970 baseball cards and bring it back."

We used to buy baseball cards at the Rexall at Orange Avenue and Carson Street or at Ryan's Pharmacy at Stearns and Palo Verde. A few years later, we used our hard-earned money for records instead, purchasing them at the strangest places—the Stones' *Got Live If You Want It* from the impulse-buy counter at Food Fair; *Blind Faith* and the first Led Zeppelin at the Singer Sewing

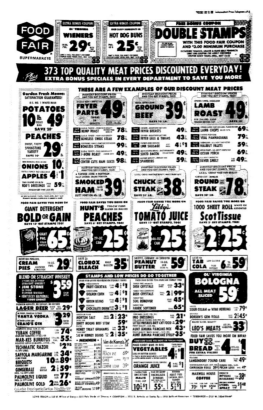

Food Fair on Palo Verde Avenue and Spring Street was a popular shopping spot for the new Los Altos housewives. *Press-Telegram advertisement.*

Machine Shop at the Los Altos Shopping Center.

White writes, "I can vividly remember walking to Wallichs Music City in Lakewood to buy our favorite 45s: 'Hey Jude,' 'Draggin' the Line,' 'Family of Man,' etc."

And there's so much more White recollects: the Angels' Jim Fregosi making an appearance at the Crest (or Towne) Theater, playing ditch-'em at Scherer Park, watching the silent movies at Shakey's Pizza on Cherry and Carson...

Tom Reilly, now of Hawaiian Gardens, has vivid memories of growing up around Bixby Knolls and points north:

The Long Beach War Surplus at Long Beach Boulevard and Wardlow Road, and another on the boulevard near San Antonio Drive, plus the Sad Sack Surplus Store on Long Beach Boulevard near Spring Street...The Jolly Jim Grocery Store, 5190 Atlantic Ave, Brownie's Toy Store at the Bixby Knolls Center...Gas was 26 cents a gallon, and they gave away drinking glasses...Bomb shelters were sold at Ximeno Avenue and Pacific Coast Highway where the Big 5 is now... Across the street from my grandparents' house on Silva Avenue there was an underground bomb shelter. A soldier owned the house and felt that Long Beach would be a target because of Douglas Aircraft.

Mike Zampelli recalls a time before the Belmont on Second Street became a fitness center, back when it showed movies. And, after the show, there'd be a trip up to Beany's Drive-In at Pacific Coast Highway and Ximeno for a Beany Burger and a Cecil Shake.

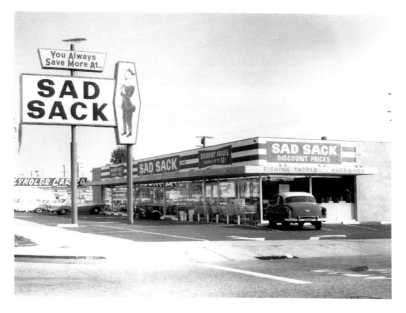

The Sad Sack Surplus Store on Long Beach Boulevard was the place for Levi's, peacoats and army fatigue jackets in the early 1970s. *Press-Telegram.*

Oh, don't get our readers started on restaurants:

Kevin Fleming recalls going to church at St. Luke's downtown and afterward going to Deno's Coffee Shop at Sixth and Atlantic for coffee and doughnuts. Or the Orbit at Atlantic and Willow, or Murphy's at Long Beach Boulevard and Willow.

"Growing up in Bixby Knolls, I also remember Welch's, Alfred's, the Tenderloin, Hamburger Henry (at Atlantic and Cartagena)," writes Fleming. "There were two restaurants with enticing displays: Brad's at Bixby Road and Atlantic had a great statue at its entrance, and Ken's on Long Beach Boulevard near Roosevelt Road had a giant polar bear at its entry."

While those places are all gone, Fleming notes that many '60s establishments are still around in one form or another in the uptown area, including the Cafe Bixby (formerly Park Pantry), George's '50s Diner ("an authentic drive-in at San Antonio Drive, earlier a Terry's, a Lyman's and its original name, Grisinger's") and Nino's.

Moving over to the Plaza and Los Altos areas, practically brand-new during the '60s, reader Carmi Standish remembers the Woolworth's counter at the original Los Altos Shopping Center, where you could get burgers and banana splits, or the old Sav-On, for the best Carnation ice cream for five cents. Plus, a

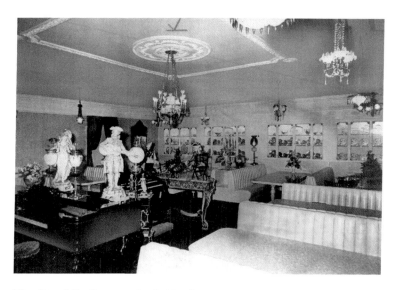

The Chandelier Room at the Golden Lantern, 2921 Palo Verde Avenue, was where the folks ate while the kids had a burger on the patio. *Press-Telegram.*

pair of our personal favorites: the Golden Lantern on Palo Verde Avenue across from Millikan High and the Bob's Big Boy on Bellflower by the shopping center.

Standish also recalled other landmarks of Long Beach's far east: "Quigley's at Spring and Palo Verde, the Unimart, which eventually became Target, on Bellflower, the Zody's Department Store on Spring and Los Coyotes Diagonal."

Marty Lavelle recalls the indispensable John's Men's Shop (featuring tailoring by Umberto) in the Los Altos Shopping Center. "John's was where EVERYBODY went to buy their clothes—Levi's, Pendleton shirts, everything," he recalls, perhaps forgetting that JCPenney, right across the way, made the only T-shirts a teen would deign to don.

David Terlinden remembered the epic moneymaking scheme of youths during the '60s: returning bottles for the deposit money. "My parents took me to the Ralphs on 10th Street, where the bottles I found at the beach fetched 3 cents apiece, instead of the 2 cents I'd get at Roger's Place on the sand. I could find three bottles, redeem them at Ralphs and buy a pair of flip-flops (on sale) for 9 cents."

Terlinden also recalled the old McCoy's grocery chain, with stores all over town. "McCoy's had a richly deserved cult following," he writes. "Where else could one get Tend'r Whipt bread (the airiest of all air bread), Golden Nugget peanut butter (in the large jar with the pickaxe on it), Banquet frozen cream pies, and so many other staples of my youthful diet?"

The Clown of the Town

Just when we're finally happy, sitting around feeling incredibly smug—smoking jacket smug—about the fact that we know everything there is to know about Long Beach, we get smacked in the face and brought back to the harsh and cruel reality that the scope of our local knowledge is damnably finite.

The latest awakening comes from Kathy Bird, who grew up in Long Beach's rough-and-tumble far east back in the 1950s and '60s.

(Her husband, incidentally, is Larry Bird, of Lakewood. If our name was Larry Bird, we'd have changed it long ago to Kareem Abdul-Jabbar.)

The Birds have a ton of those recollections, and we'll deal with more of them later, but the one thing they really schooled us about is this: Chucko the Birthday Clown started out in Long Beach.

When we were little, Chucko was huge. We had him pegged for a New Yorker or a Los Angeleno—a big-city metroclown—as we sat staring at the black-and-white Magnavox while Chucko went through his hilarious antics on Channel 7. Had we known the TV clown lived over on the 3400 block of Senasac Avenue, we would have hopped on our trike and sped over there and hung out with the then-young Larry Bird, who lived directly behind Chucko on Gondar Avenue.

Reports Kathy: "When they were little kids, all of them used to sit on his back fence and watch Chucko put on his make-up in a little glassed-in dressing room on the back of Chucko's house before he would leave to go to Hollywood for his television show, which my husband [went] to a couple of times.

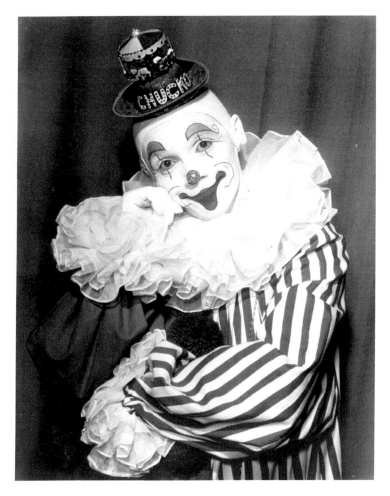

Former Douglas worker Charles M. Runyon was TV's popular Chucko the Birthday Clown on KABC and KTTV during the 1960s. *KTTV.*

"Chucko even came with his merry-go-round a couple of times to my husband's birthday parties and parties for other kids in the neighborhood."

No. Way. We couldn't even get Chucko to announce our birthday on his show, not knowing at the time that we had to meet him halfway by actually mailing in the info. To have him come to our house would have been the highlight of our career (at that point, anyway).

To find out if Kathy Bird was lying to us (you have to understand, we were taking this news very hard), we put on our hazmat gear and entered the archives, where we found clippings dating back to the years prior to Chucko landing his

TV contract in 1955. By then, he had already reckoned he'd entertained more than fifty thousand Long Beach children, always towing around his mobile electric merry-go-round, which he called, horrifyingly, the Merry-Go-Bile.

"'Mothers, sit back and relax!' That's Chucko's slogan," reads a 1953 feature on Charles M. Runyon, the man behind the greasepaint. "And that's about what mothers do when the Merry-Go-Bile appears at a party."

As the clowning business grew, Runyon quit his job at Douglas, and he and his wife, Mildred, tried expanding into all-ages entertainment with an absolutely doomed-to-fail name of the Merry-Go-Bile Caterers.

Happily, the whole "bile" thing went away in 1955 when Chucko went rubber nose-to-nose against twenty-seven other clowns and landed the TV job on KABC/Channel 7. The show aired weekday mornings (and sometimes evenings) at various times from season to season and featured Chucko interacting with kids, playing games, doing tricks, singing songs and airing cartoons.

In 1962, KABC wanted to shrink Chucko's role from full-time clown to cartoon-show host, without the kids running around in the studio. Chucko don't play that. He resigned and moved over to KTTV until 1965.

Runyon's son, Randy, took over the Chucko persona from 1971 through 1995, making occasional TV appearances on such shows as the NBC soap *Santa Barbara* in the '80s and on *The Arsenio Hall Show* in 1991.

The real Chucko, however, packed it in and moved to Grants Pass, Oregon, raising quail, ducks, pheasants and peacocks with his wife on Chucko's Bird Farm.

After our column on Chucko the Birthday Clown appeared, more clown calls came.

"Chucko lived right across the street from my house," writes Denis C. Leeds, who grew up on Senasac Avenue, which is turning out to be Clown Row in Big Town.

"Jingles the Clown lived two doors down from the Runyons (Charles 'Chucko' and his wife Mildred), so I grew up with real clowns as neighbors."

Turns out Leeds's dad was a bit of a clown himself. Writes Leeds: "Chucko and his wife went out to dinner on his birthday one night. While they were gone, my dad and three other fathers picked up a little car that Runyon drove to work and put it up on their porch."

Lisa Gelker of Avalon used the same sort of glue we did to attach herself to the TV screen when Chucko's show was on back in the late '50s and early '60s.

"Over the years, I would remember something about Chucko, and no one I knew remembered him," writes Gelker. "Even my brothers and sisters! For a time I believed he was a figment of my imagination. Thank goodness I am not completely losing my mind."

Shootin' Gallery

Kathy, who told us of Chucko's Long Beach roots, also remembers the days when cops used to practice their firearms skills at the Long Beach Police Pistol Range at 3401 Palo Verdes Avenue, where Wardlow Road and Los Coyotes Diagonal also intersect.

"Kids in the neighborhood used to call it the 'shooting gallery' and were forbidden to go near it," writes Bird. "Of course they went anyway to collect bullets and shell casings."

As more homes were built in that area that was once "out in the sticks," mothers grew more nervous about bullets flying around. Rumors of live rounds escaping the confines of the range ricocheted around the surrounding neighborhoods. The LBPD dismissed the reports, with then-chief William Dovey stating, "I think you will find that most of the slugs are coming from kids who take them from the sand in the backstop at the range and throw them around the neighborhood."

Nevertheless, the police moved the range farther out of town by 1960, relocating it to 7100 East Carson Street.

The Sound of Memories

R eaders' memories come with a soundtrack. There were record stores all over the place in the 1960s. "We'd walk to Wallichs on Lakewood Boulevard every week to check out the Top 30 singles," says reader Julie Gustav of Lakewood.

Steve Smith gave his record money to the original Los Altos Shopping Center's Musical Jewel Box. "I bought my first record there," he says. "It was a 45—'The Duke of Earl.' I brought it home and played it about

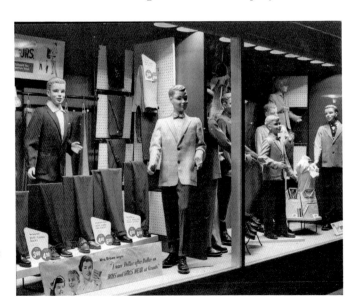

Mannequins sporting the style of the 1960s at the W.T. Grant store in Bixby Knolls. *Press-Telegram.*

60 times in a row, until my dad said he would break it if I played it one more time!"

And early far east pioneer Terry Smith began building his now-mammoth record collection at Judkins Music Co., over by City College in the shopping village near Bellflower Boulevard and Carson Street.

Debbie Hess, of Long Beach, bought her 45s at the Bixby Knolls Music Store in the Bixby Knolls Shopping Center—a bit westerly for our far east purposes, but then many of us were frequent shopping visitors to Bixby Knolls, especially if we didn't want to get all gussied up for an excursion downtown. Our Knolls-based grandma would take us for major purchases to Robert's and Grant's.

"It was loaded with other great stores," says Hess. "Brownies Toys, Horace Green Hardware, Western Auto, Anthony's."

Before the Arches

One of the most memorialized restaurants of boomers on the eastside was a simple little burger stand on Palo Verde Avenue. It was called Burgermaster, and most people who ate there have remembered it, even though it's been closed for probably thirty-five years or longer.

Steve Smith and several others recall the great burgers flipped at the little stand, where they were sold at the ridiculous price of five for a dollar. A determined and perpetually hungry younger version of us could eat five, but we were pretty aware of it afterward.

Says Smith: "My friends and I were eating Burgermaster hamburgers (after buying baseball cards at Ryan's Pharmacy across the street on Stearns) long before anyone knew what a Big Mac was."

Well, maybe before, but not long before. We recall still being a little kid when McDonald's opened over on Spring Street. Good old Burgermaster didn't last long after that.

Signage Debate

We've had three phone calls this week regarding the large Lakewood Plaza Marketplace signs going up at the newly refurbished shopping center at the northwest corner of Spring Street and Palo Verde Avenue, pretty much at the heart of what we've termed (since we moved there in '90) the Prestigious Plaza.

Of the three calls, two were against the "Lakewood" part of the name and one was in favor of it, which is interesting because that's about the way the voting went when residents of the then-new Lakewood Plaza and other Lakewood neighborhoods were electing to annex to Long Beach like mad back in the mid-1950s.

When the new, mostly three-bedroom, two-bath homes (selling generally from between $8,500 and $10,000 and change, with monthly payments on principal and interest going at about $50) began going up on what was then Lakewood land in what's now Long Beach's far east, so, too, did residents' interest in hooking up with Big Town. In 1953 alone, there were seven special elections to decide annexation in a variety of enclaves.

It was a crazy and heated series of battles, and neighborhood associations for and against annexation were formed in a frenzy.

On the pro side, you had the Lakewood Plaza Annexation Committee, the University District Taxpayers Association, Plaza Units 1 and 2 Annexation Committee, the Lakewood Village Civic League and several others.

In the other corner, you had the Carson Gardens Vote-No Committee, the Lakewood Anti-Annexation Committee, the Lakewood Plaza

Protective League, the Lakewood Plaza Vote-No Committee and, yes, others.

People in the Lakewood Plaza, a collection of neighborhoods radiating from the corner of Spring and Palo Verde, went, obviously, the Long Beach route, and all's been well—give or take some harsh feelings for a while between the pros and antis—to this point, and now the battle is perhaps warming up, this time over the signage in the remodeled shopping center that features an Albertson's, Subway, Bank of America and other shops.

One of our callers, an original owner in the Plaza, wants to retain the name for the historical purposes. "That's the name of the area, and we like it," she maintains in a phone message.

A presumably later arrival called to leave a complaint about the Lakewood connection. "My husband and I and a couple of friends were talking about it, and we said if we wanted to live in Lakewood, we'd have bought a house there. I don't like it. I live in Long Beach, not Lakewood."

Gerrie Schipske, who was councilwoman for the Fifth District in which the shopping center and its controversial signs stand, posted her stance on the issue on her blog, writing, "Time to Rename Lakewood Plaza Marketplace," and stating that she has received several phone calls and e-mails from residents in her district, mostly complaining about the Lakewood reference.

The L.A.-based developers "are doing a great job of fixing it up, but unfortunately they've made these six large signs that say 'Lakewood Plaza,' and nobody calls this Lakewood Plaza anymore, it's just The Plaza," she says.

"The developer and I talked briefly, but he's leaving the country and he said he'd get back to me when he returns," says Schipske, though she added that "he didn't seem very interested" in making the change.

It remains the Lakewood Plaza.

But nobody calls it that.

An Odd Slant on Traffic

Alan Coles, one of our neighbors over in the beautiful though sometimes baffling (boulevard-wise) East Long Beach, writes, "I've always wondered what kind of an engineer would design the Los Coyotes Diagonal, a street that starts at the notorious Traffic Circle, then goes through the messy three-way intersection of Clark Avenue and Stearns Street, then the totally confusing Bellflower Boulevard/Willow Street/405 Freeway interchange, then ending at Studebaker Road.

"This mystery has kept me intrigued for many years. Perhaps a wise person like you can figure it out."

We always smell sarcasm when the words "wise" and "you" (when "you" means us, of course) are used in the same sentence, but we're always eager to assume the writer is sincere, though, in this case, our wisdom doesn't come up with the name of the designer or idea person behind Los Coyotes Diagonal. Nor does our library.

Though we were born in Long Beach, the diagonal has confused us for most of our life as it bisects north–south thoroughfares for a while before suddenly slicing through east–west streets. What the…?

Even after we bought a house in the late 1980s near the Diagonal's northeastern terminus, we continually got our compass messed up. In fact, even after we bought the house, it took us several weeks to actually relocate it, thanks to the confusion of the sidewinding street.

In truth, Los Coyotes Diagonal isn't really to blame. Like the coyote itself, the diagonal was here before the streets to which our pads lend such fetching curb appeal.

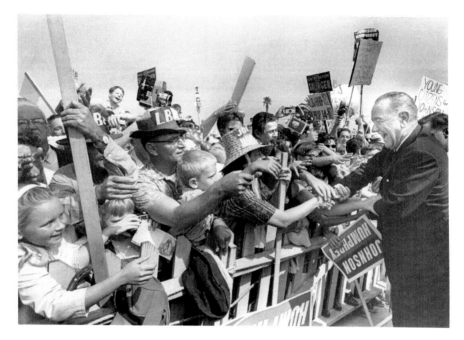

Several U.S. presidents have visited Long Beach. A huge crowd greeted Lyndon Johnson when he landed at Long Beach Airport on October 11, 1964. This photo, by the *Press-Telegram*'s Curt Johnson, won the National Press Photographers Association Picture of the Year. *Press-Telegram*.

The road began as just a dirt path, growing to a bit more substantial of a route when it was first called Los Coyotes Diagonal in 1931.

Following World War II, Long Beach began enjoying explosive growth in the eastern part of the city, and the diagonal started being pushed into use as a semi-crosstown thoroughfare.

In 1955, when the Plaza-, Los Altos– and Lakewood-area homes were being built at an oil-cooled clip, pavers were putting the finishing touches on the ten-year Los Coyotes Diagonal project, which went something like this:

In 1946, the road was paved from the Traffic Circle to Clark Avenue. Paving continued through Stearns Street in 1950 and to Bellflower Boulevard in '52. In 1954, developer Llewelyn Bixby built the dividing islands from the Traffic Circle to La Cara Avenue and paving on the Diagonal connected Carson Street with Keynote Avenue. In early 1955, the stretch between Bellflower Boulevard and Spring Street was blacktopped, and by year's end, the final length from Keynote to Spring Street was finished, allowing people to finally be baffled by the entire Diagonal while traveling in style.

During the period when Los Coyotes was getting blacktopped, part of the street took the highfalutin route and became known as Los Coyotes Boulevard, but the entire length never got on the same page, as it were. In the summer of '55, it was called "Boulevard" between Willow and Spring Streets and between Wardlow Road and Carson Street, though it remained a simple "Diagonal" elsewhere along its length.

In 1957, the road survived a more major name change effort spearheaded by friends of the late Judge Walter Desmond. The City Planning Commission voted unanimously against the proposal to rename the road Desmond Diagonal, but the Long Beach City Council dismissed that and instead voted in favor of the name change, despite protests from business owners along the Whattayacallit Diagonal.

The city council reversed itself, finally, when the judge's gracious widow, Eleanor C. Desmond, asked that the street not be renamed, because "Judge Desmond would be the last person to favor such a change if it inconvenienced or dissatisfied even one person."

When Long Beach Gave Up Smoking

When you think of the postwar baby-boomin' good life, you think of men in aprons flipping burgers on the backyard barbecue, drinking Hamm's beer and smoking Lucky Strikes, while Mom holds sway in the new kitchen over the modern electric Hotpoint range and the Philco fridge packed with Four Fishermen fish sticks and Swanson dinners purchased from the corner McCoy's Market.

And hanging over this fresh new version of the American dream were the sights and smells of burning rubbish.

On most any afternoon, you could see a half dozen pillars of black smoke rising up from yards throughout your neighborhood as though from hidden factories. The backyard rubbish incinerator was an icon of the easy life throughout the '40s and well into the '50s. In those days, there was a difference between a trashcan and a garbage can. The garbage truck hauled off your potato peels, eggshells, coffee grinds, orange peels and other table scraps. The trash—the newspaper, junk mail, rags, old boots, yard clippings—you burned in the backyard incinerator, an ugly but efficient little concrete oven outfitted with a heavy steel door and a screened stovepipe.

The most modern neighborhoods going up in the mid-'50s were designed to drive the garbage collector to the poorhouse. Houses in Lakewood were built to make that town "the largest planned garbage-free community in America," each coming equipped with an in-sink garbage disposal and backyard incinerator.

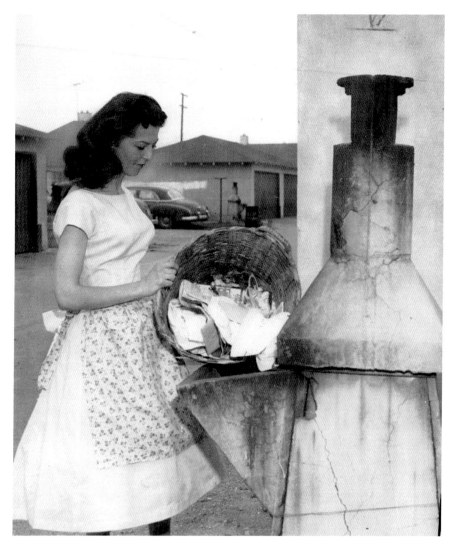

A housewife dumps the trash in a back-alley incinerator in 1950s Long Beach. The trash-burners were outlawed in 1957. *Press-Telegram.*

Incinerators had their place in rural areas where collection was impractical and the smoke issued from them was negligible, but with L.A. County's population exploding, the incinerators' output was palpable to the senses, particularly the eyes and the noses of the populace.

Even as homes were being built almost hourly in Lakewood and East Long Beach, the L.A. County supervisors were following recommendations from

the Air Pollution Control District (today's Air Quality Management District) to outlaw the 1.5 million backyard incinerators throughout the county, which, according to the APCD, were responsible for about five hundred tons of air pollution each day in the county.

From today's smug vantage, it seems like a no-brainer: more than 11,500 tons of rubbish were burned each day in the incinerators, and by the mid-'50s, smog had become a huge problem in L.A. County.

Still, there were those who were loath to trash the beloved backyard mini-monoliths. When the county supervisors recommended a July 1, 1957 deadline to outlaw the incinerators, a crowd of five hundred people stormed the board's June 9, 1957 meeting and booed those in favor of the measure. The board backed down, but only a bit. It moved the deadline to October 1, 1957.

Long Beach councilman (and hardware magnate) Charles Dooley spoke out against the ban at a meeting three months before the ban went into effect, maintaining that Long Beach was smog-free and railing against the APCD (and blundering into prophecy): "Before long, they will decide that cigarettes and pipes create smog and ban smoking, too!"

Also against the incinerator's death was the California Incinerator Association, representing the remaining nine incinerator manufacturers—down from the seventeen that existed before the banners' drums started banging. In rhetoric that would later be borrowed by the tobacco industry, the association's spokesman maintained, "We have yet to be shown any scientific experiments proving the harmful effects of incinerator smoke."

Further, he wondered, "How can you outlaw the incinerator and not the barbecue and the fireplace?"

Like this: on October 1, 1957, the fire went out in trash incinerators all across L.A. County. Today, it's easier to find a bomb shelter in Long Beach than it is to locate a backyard incinerator.

The barbecue and the fireplace, meanwhile, continue to hold their spots as icons of easy living. For now.

The Warning Wail

Reader Paul C. Schmidt informed us of something we totally already knew: "On the southeast corner of Willow Street and Palo Verde Avenue, there stands an ugly pole and device affixed thereto that I believe to be one of a number of genuine Cold War–era air raid sirens.

"I think," he continued, "that the thing used to wail on the first Friday of each month at 10:00 a.m., a practice that ended some time in, maybe, the early 1980s."

The reason we totally know about the presence of an air-raid siren on the southeast corner of Willow and Palo Verde is because for eight brisk Cold War years throughout the 1960s, we attended school at St. Joseph, on the southwest corner of Willow and Palo Verde, and that was the very siren that sent us skittering beneath our wood-grain Formica-shielded desk each month—a desk apparently specially formulated to withstand the force of an atomic bomb.

We suppose we were meant to be appeased by the loud wailing siren that went off by surprise all over the city at precisely 10:00 a.m. on the last Friday of each month. The sound signified our readiness for anything the Russians cared to throw at us.

The '50s, we understand, were much colder, war wise, than the '60s. It was 1949 when a few early-warning sirens first went into use, mostly at airports and harbors. In the 1950s, they began springing up all over town like derricks in oil country.

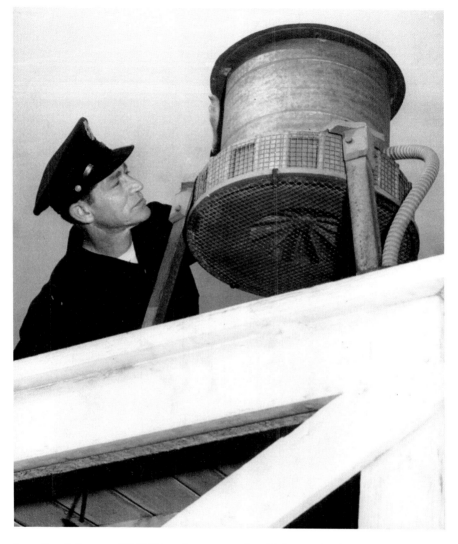

Long Beach fireman Bill Williams inspects an air-raid siren at Station No. 1 in 1956. *Press-Telegram.*

But not much of the bloom was off our fear of the Ruskies in the '60s (see Crisis, 1962 Cuban Missile), though the skepticism regarding the efficacy of school desks had surfaced at our school.

"You realize we're all gonna die if an A-bomb goes off anywhere near this place," a fellow student of war and ordnance would mutter 'neath our fallout furniture.

"Duh," we'd reply, in the argot of the day.

Some strategists among our classmates would note that 10:00 a.m. on the last Friday of the month might be the best time for the Red Menace to

A former Nike missile vault at Long Beach Airport was converted into an underground Emergency Operating Center in 1969. It has since been demolished. *Press-Telegram.*

shower our shores with atomic or hydrogen or nuclear weapons, when the local sirens would all be wailing wolf.

The local Civil Defense and Red Cross sold post-atomic holocaust "survival kits" in area grocery stores. Meant to get a family of four through three post-bombing days, the seven-dollar packages contained large cans of orange, grapefruit and tomato juices; evaporated milk; cans of green beans, peas, potatoes, baked beans, peaches, apricots and applesauce; whole-wheat cereal; graham crackers; Ry-Krisp crackers; luncheon meat; tuna; raisins; hard candy; instant coffee; salt; gum; and a can opener.

Of course, some of the civil-defense wailing was the source of whining. In its early days, local residents' complaints included: "It sounds like an ordinary siren," "I can't hear it where I live" and the perennial beef for all occasions, "It's not as good as it was in the last war."

By 1968, the siren's song warning of approaching enemy was such a part of everyday life (albeit monthly everyday life) that it was barely noticed. We ducked under our desk with that lazy sullenness of a thirteen-year-old boy, if we did it at all in '68.

By then, local police departments and city officials were bombarded each air-raid Friday with phone calls from residents wondering what's up with that sound, as if amnesiacs were getting re-hit on their heads by bank safes.

Which doesn't mean city officials thumbed their collective nose at the idea of civic annihilation. Against the day when Long Beach would be destroyed, a nice little subterranean shelter was made at Long Beach Airport. A Nike missile base command post was converted into an Emergency Operating Center, in which the city's best and brightest (pretty much the mayor and councilmen) could reside and run the city, such as it would be. That's since been demolished in favor of a moneymaking office park.

Around town, sirens kept up their false-alarming howls for decades, all the way through to the final Friday of use in 1991.

A decade later, when Homeland Security had become the new Civil Defense, lots of ideas were tossed about in terms of pre-terrorist alert systems. And there was talk of recommissioning whatever rusty, old air raid sirens still remain.

The idea didn't get far, and anyway, who would listen?

The Russians Were Coming!
The Russians Were Coming!

In 1957, *Press-Telegram* reporter Bob Wells interviewed Long Beach residents and business owners to find out what plans they had in the event of the Big One being dropped on Big Town. Some responses:

- "I guess if we had an air raid here in Long Beach, the family would go into the hall, shut all the doors and lie down on the floor. What else could we do?"
- "We'll stay home and say our prayers. What else can you do with 15 minutes warning?"
- "I've read what to do in the newspapers and I've seen special programs on TV. I know we're supposed to take cover in the safest place at home, or wherever we are, keep the radio on for instructions and stay inside after the bomb blast for fear of radiation. Other than that, I haven't made any special preparations."

One day in April 1961, four of the city's thirty-nine air raid sirens blared for more than an hour because of a short circuit in the system. A few people were alarmed by the alarm, but more people were irritated by the noise. Newspaper and police switchboards were clogged with calls. "Everybody did everything wrong," griped a Civil Defense coordinator with the police department.

"When a siren screams constantly, it means an attack is under way," he said, although that wasn't what it meant in this case. Still, he said, "people should seek shelter or evacuate. Also, you should turn on your radio. The last thing to do would be to tie up communications by using the phone."

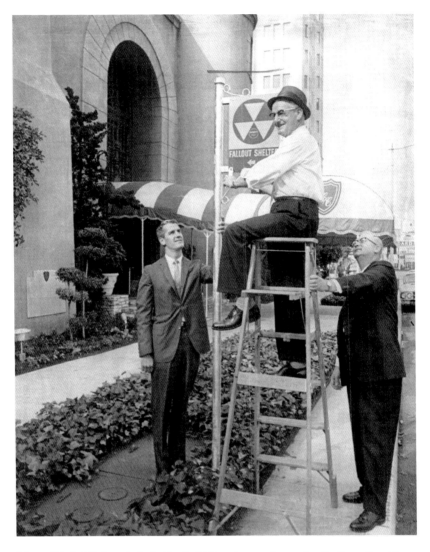

Mayor Edwin Wade scaled a ladder in 1962 to inspect the marker for Long Beach's first public fallout shelter, in the basement of the Pacific Coast Club on Ocean Boulevard. *Press-Telegram.*

In contrast to today's ultramodern precautionary formula of duct tape and plastic wrap, the survival kit suggested by Civil Defense officials in 1955 was the stuff of picnics in the park.

The so-called survival kits were meant to last four persons three days in the event of atomic attack and were offered for sale by the local Civil

Defense and Red Cross with advice from nutrition experts for seven dollars at several Long Beach markets.

What would get you and your three companions through your atomic campout would be a large can each of orange, grapefruit and tomato juice; three one-quart cans whole milk; one twenty-ounce can each green beans and peas; two cans potatoes; one twenty-eight-ounce can baked beans; one large can evaporated milk; one twenty-ounce can each peaches, apricots and applesauce; one fifteen-ounce package whole wheat cereal; one seven-ounce package each of graham crackers and Ry-Krisp; one twelve-ounce can luncheon meat; one six-ounce can tuna; one fifteen-ounce package raisins; one eight-ounce package hard candy; one nine-and-a-half-ounce package instant nonfat powdered milk; one two-ounce can instant coffee or tea; six small packages salt; three packages gum; and one can opener.

And, as always, keep your butt up and your head down.

The Scourges of the Sidewalk

In the late 1960s, there were two possible scenarios we foresaw regarding what we would be driving in the twenty-first century: rocket space-cars like the Jetsons drove or autoettes like the old people drove. We would've been filled with despair if we'd been told that when the twenty-first century started, there'd be nothing like a space-car in General Motors' pipeline, and that the autoette would, long before we reached the age of AARP, be driven from the streets or, more properly, the sidewalks of our town.

"Autoette" was a trade name turned generic term for the little three-wheeled electric carts that once seemingly outnumbered pedestrians on the streets of downtown Long Beach. The vehicles were apparently handed out to the town's more seasoned citizens once they reached the age of driving incompetency, whereupon they would take to the sidewalks in significant numbers and drive up the heels and over the backs of whippersnappers who didn't have the God-given sense to steer clear of a determined errand-runner behind the wheel of one of these "buzz-bombs," as they were not necessarily endearingly termed.

And "behind the wheel" is a misnomer. The carts were steered by means of a stick with a handle on it. The things were a snap to drive, and the oldsters helming the little things terrorized the sidewalks of Pine, Long Beach Boulevard, Ocean and other downtown streets for a couple decades.

Even a *Press-Telegram* editorial urging younger adults to be more tolerant and friendly to "the elders" acknowledged that this wasn't always easy, granting that "it is a bit disconcerting to have to dive out of the way of a

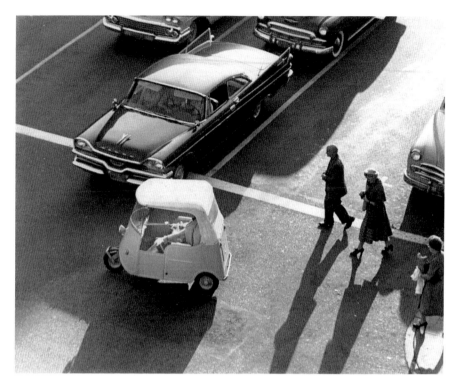

Pedestrians and drivers alike had to be on the lookout for autoettes downtown in the 1960s. *Press-Telegram.*

granite-jawed, near-sighted speed demon of 85 who thinks pedestrians are fair game."

We will further note that some autoette pilots were repeat drink-and-drive offenders who took to the transportation because you didn't need a driver's license to operate the electric carts on the sidewalks. So, it's not fair to say all autoette drivers were elderly. It's more balanced to say that they were all elderly and/or drunk.

In 1964, police estimated there were 3,000 electric cars zipping around in Long Beach, but it seemed like there were more (columnist George Robeson put the figure at 7,420,000) if you were a pedestrian on Pine in those days. Sharp-eared shoppers who were lucky enough to hear one approach would paste themselves against storefronts or dash out into the street to take their chances against the merciful braking power of automobiles.

The city was more than accommodating to the fleet of autoettes, carving cut-outs into the curbs or building sidewalks at street level at intersections

so drivers wouldn't have to slow down on their headlong rush to wherever it was they were going—generally either Thrifty or Woolworth.

Laws slowly whittled away at the autoette's reign of terror, with each ordinance becoming a source of outrage to the electric motorists. In 1964, pedestrians were given the right-of-way over electric cars, but it

Before they were outlawed, autoettes were sidewalk hogs along Pine Avenue downtown. *Press-Telegram.*

was a foolish stroller who depended on the law. There was a strong sense of entitlement among the sidewalk autoette drivers—almost as strong as their kamikaze instincts.

Although the carts, by 1965, had become classified as motor vehicles and therefore illegal to operate on sidewalks, the law was scantily enforced. The last thing anyone wanted was for these things to take to the streets in large numbers.

It took a tragedy—or maybe it was the specter of unlimited lawsuits being filed against the City of Long Beach—to eventually eradicate the autoette from the sidewalks of downtown. In 1966, an eighty-year-old woman plowed her autoette into a ladder holding a fifty-one-year-old neon-sign installer, who fell fourteen feet and died as a result of his injuries.

The ensuing lawsuit was settled out of court in 1971, and Long Beach's city attorney informed the council that the city would be liable for all further accidents occurring on the sidewalks. The council determined that the law would be enforced. And so it came to pass.

The drivers, given the heave-ho from the sidewalks, found they were no match for the real road hogs in their automobiles, and their numbers dwindled dramatically—to be replaced by kids on skateboards.

It's all part of transportation's Circle of Life.

Everybody Wanted the Freeway That Everybody Hates

To travel on the crumbling, potholed, cracked and divoted Long Beach Freeway these days is to almost experience what automobile travel was like before the days of concrete and asphalt: a jaw-bustin', gutwrenching, axle-snapping journey—that is, if you can build up the necessary speed.

But when the freeway was finally largely completed in July 1958, the $48 million, 16.5-mile roadway was called "the freeway everybody wanted."

And they wanted it for a long time.

Even the first automobiles still had that new-car smell in 1913 when U.S. engineers proposed a flood-control channel along the L.A. River. The artist's conception showed broad highways on both banks of the river. Later, there was talk of putting the freeway in the bed of the river itself. Now, we're no engineer, but…

It was back to the drawing board until 1943, when a master plan of freeways for all of L.A. County placed the proposed "L.A. River Freeway" pretty much parallel to, but apart from, the creek (of which it was once said that the Mob killed a guy by putting his feet in concrete and tossing him into the L.A. River, where he died of thirst).

Before actual construction began on the freeway, there was the matter of the name. The Long Beach Chamber of Commerce moved to have the name changed from the L.A. River Freeway to the Long Beach Freeway. The change was initially blocked by a county supervisor who contended that the name would be confused with Long Beach Boulevard, but it was explained to him that, see, "freeway" and "boulevard" sound completely different. The supervisors OK'd the name change in 1951, the year that construction began on the freeway.

The "freeway that everybody wanted" moniker stemmed from the fact that no organized group took a stance against the construction of the freeway, which was initially conceived as a route connecting Pacific Coast Highway to the Santa Ana Freeway.

To build the road, 1,200 parcels of land for a right-of-way had to be obtained at a cost of $20 million. Twenty-three contracts totaling $28 million were awarded to thirteen different firms to build nine bridges and ten different sections of road. The freeway required the relocation of part of the lines of the L.A. Junction Railway and spanned the Pacific Electric, Union Pacific, Southern Pacific and Santa Fe tracks. Sewer lines were revised and rerouted, several city streets and county roads were altered and a pair of dumps was removed.

The dream of the freeway came true in stages, with various sections opening as they became complete. Then-governor Goodwin J. Knight rode in a limo on the first part of the freeway that opened October 29, 1954. The original final link was open to traffic on July 10, 1958, with ceremonies conducted on the freeway just south of Imperial Highway (attended by the usual gaggle of beaming city officials and lesser legislators). After the ribbon cutting, autos were allowed on the road, which allowed them, under ideal conditions, to, for the first time, zip effortlessly and ceaselessly from Long Beach to L.A. and back.

The road was as smooth as silk on opening day, years before trucks were developed that would be big enough to pulverize the road just by driving on it. It hardly needs to be said that, also on opening day, traffic was a mess.

First Day on the 405

If we were a freeway, we'd be the San Diego Freeway. Our history and that of the 405 are inextricable. Construction began on the freeway in 1955, the year we were born, and the freeway was completed on January 12, 1969, our fourteenth birthday.

Our first brush with The Man came in 1961, when we were busted while playing war (World War II, European Theater of Operations) with our neighborhood allies amid the wreckage of eminent-domained houses that were brought to rubble to make room for the freeway through the Los Altos part of town, around Petaluma and Ostrom Avenues north of Atherton Street.

Most kids played war in normal residential areas; our version of play battle was blessed with the verisimilitude of seemingly freshly bombed houses. Still, we weren't supposed to be there, and the police gently marched us back to peacetime suburbia.

Subsequent brushes with the law came on the 405 in the mid-1960s when the police were called pretty much round the clock to usher us off the incipient highway for flying kites in the fast lane, riding with neighbor kids on Sting-Rays down off-ramps or just rummaging around the shoulders, despite hair-raising rumors of blasting caps littering the area, any one of which would, best-case, blow your arm off at the elbow.

And life for residents near the construction site was nasty, brutish and noisy. Homeowners debated which was more calamitous: having your home demolished in the freeway's path or having it spared, only to remain, severely devalued, a couple hundred yards from the freeway, as ours was.

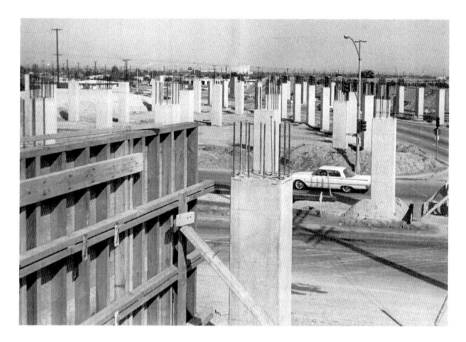

Pilings for the San Diego Freeway at Bellflower Boulevard and Los Coyotes Diagonal puzzled motorists in 1962. *Press-Telegram.*

The debates were conducted loudly, so as to be heard over the constant ground-shaking cannonade from mammoth pile drivers (we called them the Big Boom Machines) and the diesel rumblings down the streets from battleship-sized semis filled with rubble being taken away from the freeway site or rubble being brought into the freeway site.

The pilings and piers that would hold the road, strange gray monoliths spouting branches of dark brown re-bar at the top, popped up all over town in the early '60s. Later came the topper, the mostly elevated superhighway of the (near) future. Speculation abounded about how quickly we'd one day be able to travel from our home in Point A to the wondrous and distant destination of Point B.

The section of the San Diego Freeway that most affected our life was a 6.5-mile stretch of the 405 that connected Los Alamitos Boulevard to Atlantic Avenue—the off-ramp we'd take to get to Dad's and Granddad's business and to our grandparents' house. It was finished in 1964 and used up about 120,000 yards of concrete, 300,000 tons of sub-base material, 240,000 tons of crushed rock and gravel, 8 million pounds of bar reinforcing steel, nine miles of reinforced concrete pipe for storm drains

and fifty thousand feet of (pre–Lady Bird Johnson freeway beautification project) chain-link fence.

The section's cost was $19.5 million. Today, that's a disappointing lottery jackpot win.

The opening of the freeway section at 2:00 p.m. on October 1, 1964, was a space-age event. A laser beam was aimed at a chain stretched across the eastbound lanes below the Walnut Avenue overpass. The chain burst, and almost immediately, the road played host to its first traffic jam.

For years, our pop had taken surface streets to his shop on Atlantic but was looking forward to breezing home at five on the three-hour-old San Diego Freeway.

Your *Press-Telegram* reported the story about how the section opened with "a few public speeches followed by thousands of private, profane ones. Motorists were stymied in one of the biggest traffic jams in recent years."

It took Dad more than two hours to make the short jaunt on the road that was filled not just with people driving home but also with untold numbers of people wanting the inaugural experience of breaking in new road, which, for the first week, only carried eastbound traffic.

Opening-day commuters, reported the paper, "were greeted by cold wives and cold dinners.

"Several thousand frustrated drivers were caught in the three-hour, smog-bound tie up. Scores of autos were forced to the side of the road to cool off."

The news account continued: "In Long Beach residential areas adjacent to the new freeway, housewives and school children sat on porches and front lawns to wave encouragement to distraught drivers foundering on their maiden venture on the new link."

And that would've included us. We had hopped on bikes with our friends and gone to gawk at the 405, where it cut through the site of our combat campaigns of just a few years past.

The cars weren't whizzing by at the Jetsonian hyperspeed that we'd envisioned. Still, aside from the fact that dinner would be late that evening, we had few worries: by the time we'd be old enough for a license, we'd be driving rockets.

The Milk Bowl

The Milk Bowl's first kickoff came in 1948, when Harry Moore (the Moore League Harry Moore, that is) and then district superintendent Douglas Newcomb (the Newcomb Academy Douglas) came up with the idea of having the Long Beach schools' football teams play a brisk quarter of ball against one another, with the ticket proceeds going to the PTA's Milk Fund to purchase, yes, milk, but also other supplies for students who would otherwise have to go without.

The first Milk Bowl was held at Wilson and drew 5,700 fans to watch the three schools of the day—Wilson, Poly and Jordan—play. Who won? It's not important, which is our way of saying Poly.

The first two Milk Bowls were season-ending affairs, with the second, held at Jordan's field, occurring on Thanksgiving eve.

After that, they became sneak-preview events as fans throughout the city came out at the front of the school year to get a look at not just the varsity squads but also the JVs (called Bees in the day) and the cheerleaders, pep squads and bands. We wish we could've been at the first game, when Jordan's marching band formed a giant milk bottle formation at midfield while playing "The Farmer in the Dell."

The Milk Bowl rotated among the three schools, gaining in popularity each year. In the mid-'50s, it moved to Veterans Stadium.

Millikan joined the Milk Bowl fray in 1956 in front of a crowd of 13,826, and Lakewood signed up the following year to help celebrate the newly formed Moore League.

The Milk Bowl's cup ranneth over in 1970, drawing a career high of 18,391 at Vets. It was a huge citywide event that had a great party vibe.

In 1990, Dave Radford, who was then Millikan's football coach and who played on Millikan's first team in 1956, told the *Press-Telegram*, "It's an experience to see fifteen or sixteen thousand people who are excited to see you. It had a Mardi Gras feeling."

The feeling passed after the 1970 peak, with crowds diminishing in each successive year.

Still, milk money came in at a pretty good clip for a while—and not just from ticket sales. Area merchants and faithful alumni could be counted on to kick a bit of coin into the milk can.

But the weirdest source of funds came from disaster master filmmaker Irwin Allen, who donated $4,000 to the milk fund in 1976 in exchange for filming the crowd for his not-easily forgettable 1977 movie *Viva Knievel*, which starred Evel in his title role, plus Gene Kelly, Lauren Hutton, Red Buttons, Leslie Nielsen and Frank Gifford.

The quick answer, as is often the case in "Whatever Happened To...?" mysteries, is that people lost interest. Better things to do with our time? Coaches not wanting to give away strategies or risk injuries in meaningless scrimmages? Video games?

The last Milk Bowl, a no-fat affair that featured only freshman and sophomore scrimmages, drew fewer than one thousand folks in 1989, and it was dropped altogether the following year.

Hope Grew on the Honor Farm

A city prosecutor before three hundred members of the Men's Bible Class of Long Beach first proposed the need for an honor farm in Long Beach in 1949. Spreading his own brand of gospel, Kenneth E. Sutherland told the men in the First Baptist Church, "Our bulging city jail, built to accommodate just half the inmates now serving time there, is not the answer to our tragic and increasingly serious alcoholic problems."

The answer, it was proposed, would be a place a lot less like a jailhouse and a lot more like a farm, a plot of land that could be worked by inmates who didn't pose much of a threat to society—mostly alcoholics, with a smattering of traffic violators.

It would take a while for the seed to germinate.

Rarely in the history of Long Beach and its surrounding communities has there been a greater Not In My Back Yard movement than that which arose once the honor farm idea grew closer to reality in the '50s.

The site selected for the honor farm was south of Carson Street, just east of the San Gabriel River. The opposition—most often people who feared serious drops in property values as well as serious threats from alcoholics who made it over the insignificant wall that an honor farm would require—included enough organizations to squash most projects, among them the Lakewood and Artesia Chambers of Commerce, the Veterans of Foreign Wars, the Los Altos Association, the Hawaiian Gardens Improvement Association, the South Artesia Taxpayers Association, the Long Beach Board of Education and several others.

Nevertheless, the Long Beach City Council, with strong prodding by Police Chief William Dovey, voted to approve the project, and on March 21, 1954, the twenty-three-acre site, containing barracks for a few more than one hundred men and plenty of land for them to work, was opened, and forty-two alcoholics, vagrants and traffic law violators were moved crosstown to begin serving their time as honor farmers.

The honor farm opened as Rancho Esperanza—the Ranch of Hope (no serious thought was given to a newspaper columnist's proposal to dub it "Dovey's Tavern")—and was an immediate success.

About eight months after opening, the farmers were growing almost enough food to feed themselves on a pair of plots, one three thousand square feet and the other about five thousand square feet.

The farmers worked every day from 7:30 a.m. until 4:00 p.m. planting and growing sweet corn, tomatoes, cucumbers, radishes, onions, squash, watermelon, cantaloupes, black-eyed peas, string beans, lettuce, parsley, carrots, turnips and bell peppers.

Soon, they were not only feeding themselves but also trucking surplus back to the more serious offenders confined to jail at city hall.

No machinery was used in working the land, just the backs and muscles of the worker-inmates, who themselves gave the place rave reviews:

"First time I've ever had decent living conditions," said one.

"I feel like I can go back to work when I get out of here," said another.

On Sundays, most prisoners attended church service in the honor farm's chapel. In the evening, they watched television and attended weekly Alcoholics Anonymous meetings.

The land by the river had previously been deemed poor farmland, but the workers kept at it with compost and intensive tillage and cultivation until it was as fertile as the Central Valley. In July 1955 alone, the harvester-inmates hauled in 4,247 pounds of vegetables.

There were no assurances or even much in the way of expectations that most of the inmates would be "cured" of their alcoholism. Indeed, many were repeat farmers, spending more time inside than out.

In 1968, an honor farm official estimated that about 80 percent of the inmates were there for alcohol violations, and of these, about half were repeat offenders.

But still, the farm provided the hope from which it took its name, and many, after a few weeks of honest and dry work at the farm, swore off booze for good. Or at least were never seen at the farm again.

Hope ended, however, in the wake of the massive cuts caused by Proposition 13, and Rancho Esperanza was closed in the late 1970s.

The place remained a farm, however; it was converted for use as community gardens.

A Little Story About Midget Town

There is something in the human soul that yearns for the existence of a Midget Town.

If people had their way, there would be a Midget Town, or Midgetville—yearnings vary on the name (anyway, the politically correct term used to supplant "midgets" is "little people")—which would be populated by, according to most legends, retirees or escapees from circuses or carnival sideshows.

Typically, these minivilles are incredibly difficult for regular-heighted people to find—either stashed away in hidden locations or guarded by barricades or, minimally, fences.

Still, people know about them. A brisk romp through the Net uncovers one in Totowa, New Jersey (the residents "are very hostile and throw rocks at you," according to a Net poster); one in Cincinnati (a correspondent reports, "It looks like it was built for kids to play 'town' in or something"); one in San Diego ("the houses all look normal except the windows are low and the doors are small"); and, of course, one or two in Long Beach ("apparently," writes an anonymous poster, without saying why it's apparent, "these dwarfs live by their own laws and are exempt from California state law").

It is a rare season that passes without a reader asking us where one can find Long Beach's Midget Town. They already know of its existence from reading first-person accounts on the Internet.

One such storyteller spins a saga about how he was dumped in Midget Town in Long Beach one night after hours of heavy drinking. Our man passed out on a lawn and awoke hours later to find a little person swearing and throwing

lemons at him. The storyteller stood up, he says, and other little people began chasing him around for thirty minutes before he finally escaped. Problem is, "due to my drunken state, I do not remember where I was."

Another tells about a co-worker who, with some friends, went out in search of Long Beach's Midget Town and found it, during which some sort of misadventure occurred: "I have asked my coworker, but last time I spoke with her she was still too distraught from the memory of whatever happened…"

And our most recent e-mail query comes from a woman who writes, "A guy I work with told me about a time when he and three of his friends got lost in 'some neighborhood' in Long Beach (they're from Lynwood) and ended up in a gated community of tiny houses. It was around dusk and there was a little person watering his lawn who yelled at them that they didn't belong there and if they didn't get out he'd call the security guard."

The truth is hardly satisfying. Not–Midget Town is La Linda Drive, a gated cluster of mini-mansions built along an oblong drive in the heart of Long Beach's Los Cerritos neighborhood.

The street's history goes back to the early days of the city when it was a carriage path that circled the property and mansion of George Bixby, whose father, Jotham, ran Rancho Los Cerritos and was instrumental in forming the city of Long Beach.

When George died in 1920, his widow, Amelia, sold the property to Oklahoma oilman Thomas Gilchrist, who subdivided the land and gave the neighborhood its name.

The Midget Town rumor clearly sprouts from the pairing of the secretive gate and fence that hides La Linda from casual view with the fact that the neighborhood's streets are narrower than normal and its tiny lots hold enchanting homes that could look like miniature mansions.

There is no truth to the rumor—our favorite one connected with the La Linda legend––that the enclave was built by and for little people who had acquired their wealth by playing the roles of the munchkins in *The Wizard of Oz*.

In fact, calls and letters continue to come in verifying, to various degrees of credibility and clarity of memory, the existence of Midget Towns, both in Downey's "Island" neighborhood and Long Beach's Los Cerritos/Bixby Knolls area. Both locations have been debunked as little-people centers several times, but then they start getting bunked again by believers, eyewitnesses and people who just happen to know the truth, like Joel Vasquez, who e-mailed us straightforwardly: "Midget Town is located at the end of the cul-de-sac on Rivergrove Drive in the city of Downey. This is according to my brother and his friends."

That would be in Downey's "Island" section, a little hood that bulges out across the Rio Hondo in the city's great northwest. A Mrs. Emmi called to tell us that she lives on the Island and that she hasn't seen any sign of a little-people enclave but does remember hearing about them many years ago.

"At one time there were little people here working with the circus," she recalled. "Actually, I think they lived along the river. I think they were squatters."

Or, she says, perhaps it was all a rumor.

And still the letters poured in:

"I graduated from Millikan in 1972, and it was a known 'fact' among my crowd that there were midgets living in the Bixby area of Long Beach," recalls Debbie Fawcett.

"On many a Friday night, in various altered states, Becky, Debbie and I drove down the narrow alleys looking at the proof of their existence—small, round, brick-lined doorways choked with creeping ivy. Alas, neither troll nor dwarf ever emerged from those brightly painted doors. Still, it was scary."

A more, shall we say, "vivid" report comes from a correspondent who we'll just call Nod, which is his real-life nickname.

Nod's journey to Midget Town also came in the '70s, "when three of my friends and I were drinking brewskis.

"I had just picked up a bag of mushrooms, and we decided to go to the golf course [Virginia Country Club] when it got dark, eat the mushrooms, then run around the golf course with our Bic lighters just flicking away." Oh, we're going to be seeing midgets all right.

Time passes.

Nod continues:

I was lying on what I thought was the golf course staring up at the morning light. I heard sounds like stones skipping on water; along with voices through a tunnel...I rolled over and looked up to see that I was in the front yard of a house on a hill. There were two people (little people) yelling at me. I didn't understand what they were yelling (little people language). Then apples started landing around me. I realized I was about 10 feet from the house, and I saw all the windows and doors were low, like Alice in Wonderland. *I ran and ran and eventually found my way home.*

There are two leading theories about the true site of Midget Town in Long Beach—one is La Linda Drive in Bixby Knolls, the other is the end of Virginia Road in Los Cerritos. We've visited both locations several times, though never at night and always sober, and while most of the people

we've seen there are smaller than us, that isn't saying much. Both sites are somewhat curious in their seclusion, a curiosity heightened by the fact that they're gated.

You might have some luck looking elsewhere: "I never heard about the Long Beach one, but I heard for years that there was one in Austin, Texas," writes Gini Ward.

Pam, in Long Beach, e-mails a report from a friend who grew up in Downey: "You could touch the roof [of the houses]. It was off a dirt road near the Downey-Sanford Bridge. We used to ride our bikes there."

And reader Cyndi Saiza remembers her dad, a construction worker, who had occasion to work on "midget housing" in Hawaiian Gardens.

"He would tell me about the inspectors having to get waivers for the height adjustment," she recalls. "He said he had to adjust his thinking to install items (for little people), including sinks, toilets, showerheads. He said it gave him a new perspective on the lives of other people."

One of our favorite Midget Town letters came from Lector Orrick, a Long Beach native who said he was "born in 1939 in the old Seaside Hospital, so I'm not the run of the mill 'crackpot.'"

Orrick recalled midgets congregating in the old Towne Theater (4425 Atlantic Avenue) back in the early '50s "most every Friday night."

He reported:

> They sat together as a group in the very front row. The ushers would constantly shine their flashlights on them and tell them to be quiet. It was never a loud noise, but more like constant chatter.
>
> When the movies ended—you saw two in those days—the midgets hastily made their way out the emergency exit, stage left, which basically put them on San Antonio Drive, and then they headed west toward Virginia Country Club. Though I was not taking a head count back then, I would say the group varied from three or four to 20 or so. A lot depended on the weather and what movies were playing.

When we were young, we recall going to the Towne, too (we sat farther back). We preferred, however, the more glamorous Crest Theater at 4275 Atlantic, and we never saw any chattering little people, although, now that we think about it, maybe we WERE the chattering little people! But no. Orrick says the manager of the Crest in those days was avidly anti–little people. "He was the one who always came down hard on the midgets if they tried to get in."

Most of the more fleshed-out little-people-in-Big-Town reports have the little people living a life of semi-retirement, paid for by the reported fat salaries they earned playing munchkins in *The Wizard of Oz*. Mr. Orrick's report elaborates: "I had always heard that these midgets were not only part of many supporting casts in the movies, but many of them also worked at Welch's Restaurant, right on the corner of San Antonio and Atlantic."

Orrick is fairly certain that, even though they might not be there now, they did live at La Linda Drive.

"Hope this info helps," he writes. "Certainly, other interested readers can come forward now and confirm most of this information. The only reason you are having a problem of actually pinpointing Midget Town is that the people who know exactly where it was don't want to step forward and be made out to be a fool."

The Closing of the Opening Bridge

During our tireless and apparently ceaseless journey into Long Beach's past, we've come across some people with fond memories of landmarks now long gone that we wouldn't have thought would rank high in that cherished place that's close to the heart: the hoodlum-packed area west of downtown known as Jungleland, for instance.

But, of the scores of memories to have crossed our desk in the last couple of weeks, the most surprising have been the fond feelings people have for the once-reviled pontoon bridge that spanned the entrance to the Cerritos Channel in the Port of Long Beach.

"Hi, Tim," begins a message from Thelma Keiffer, one of four happy, pontoon bridge–related reminiscences we've received of late. "I used to really like driving over the old pontoon bridge. How about you?"

Well, Thelma, not so much. As we recall (and we have a thick batch of yellowed clips here to back up our battered memory), a trip across the bridge was always nasty, sluggish and packed with motorists who drummed their fingers on their steering wheels waiting for barges and scows to pass through the opening made by the retractable bridge before they (the motorists) could continue on their merry way to the wonders and joys of Terminal Island.

The U.S. Navy built the floating bridge in 1944 at a cost of $750,000 as a wartime emergency measure to allow easier access from Long Beach to Terminal Island. Prior to the bridge's opening, a forty-foot ferryboat called the *Fortuna* carried workers across the channel twenty-five at a time. The

The pontoon bridge in the harbor was closed on July 1, 1968, when the Gerald Desmond Bridge replaced it. *Port of Long Beach.*

bridge, on the other hand, carried as many as twenty-three thousand cars in a twenty-four-hour period.

What caused all manner of cussing and vilification was the length of time motorists had to wait while the bridge retracted to allow ships to pass through. The bridge consisted of two concrete pontoons, each 51 feet wide by 135 feet long and 13 feet deep. They were pulled apart mechanically to create a 170-foot opening for ships using the Long Beach Harbor Entrance Channel.

In addition to some epic traffic jams at the bridge as cars backed up waiting for ships to pass through, a source of frustration for bridge-using motorists was the frequent closure of the bridge for repairs or adjustments. A flickering lantern would often alert motorists on the southbound Long Beach Freeway over a sign reading "Pontoon Bridge Closed."

The reason for the closures generally had to do with subsidence problems caused by oil being pumped out of the harbor area, resulting in the ground sinking. In these cases, the bridge would have to be adjusted. When the subsidence problem grew worse in the mid-1950s, the bridge had to be moved about one hundred feet north of its original location.

The subsidence level, and low tide in general, also added to the frustration—and horror—of motorists. The drop from Seaside Avenue to the bridge was a real cliffhanger as cars traveled nearly straight down for fifteen feet, crossed the channel and then faced an equally precipitous climb at the Terminal Island end.

On July 1, 1968, after the opening of the Gerald Desmond Bridge, the last car, driven by Val Deaser, chief maintenance supervisor for the Port of Long Beach, crossed the pontoon bridge and signaled the bridgeman to open the bridge up for the last time. It's one of those weird wordplays: a pontoon bridge forever open is a pontoon bridge forever closed.

More Blasts from the '60s

Los Altos and the Plaza and chunks of Lakewood were born at about the same time as most of the readers who share their memories of growing up in those neighborhoods.

"In my neighborhood we had the Helms bakery man, we had the Good Humor Man, we had the milkman," recalls Diane Lowell (or something like that; the recollection came in over voice mail). "We had mail twice a day; we had a morning and an evening newspaper. We had the Lakewood Theater—at the intermission between the two features we got up on stage and danced—and the Lakewood Drive-In."

Bill Snyder remembers the Lakewood walk-in, too. And then, after the movie, he writes, "we'd cross the street to Cisco's Hobby Shop to check out the new model kits, then to the Rexall Drug Store to read comics out of the rack till the manager told us to buy one or get out."

Randy Lewis also has swell memories of theaters, especially the Crest on Atlantic Avenue in uptown Long Beach.

"I still have my original ticket dated Saturday, March 14, 1963, for the first American concert the Beatles performed, in Washington, D.C., that appeared on closed circuit at the Crest," writes Lewis. "The cost of the ticket was $2.50. I was 8 years old. It was in black and white and I couldn't see anything because everyone stood up."

Lewis also recalls Murphy's Drive-In on the northeast corner of Long Beach Boulevard and Willow Street, where he had "the best fish and chips dinner ever."

A look westward on Belmont Shore's Second Street in 1963. *Press-Telegram.*

Drive-ins? Fish? Nat Tucker recalled Oscar's Drive-In, on Pacific Coast Highway just south and east of the Traffic Circle. "Their specialty was a great, big fish sandwich that only cost fifty cents," said Tucker. Actually, after

Many a future yachtsman got his first set of sea legs in sabot sailing classes in Alamitos Bay. *Press-Telegram.*

consulting the Repository of All Knowledge (an old box in our garage), we found that "Oscar's Sensational Deep Sea Sandwich" ("two big pieces of the finest fish filet, deep fried, served on a toasted bun with Oscar's tartar sauce, crisp lettuce") went for forty-four cents.

Long Beach history expert and videographer Dennis Morawski recalls live music in long-gone theaters, including "a great show at the Fox West Coast featuring Chuck Berry in '69 or '70.

"I'd seen Chuck before and I've seen him since, but never as good as that night," writes Morawski.

A more popular rock hangout during the '60s was the Cinnamon Cinder on the Traffic Circle. "I was a regular at the Cinder from 1966 until 1970," writes e-mailer Janeyb777. "I saw Ike and Tina there, Jackie Collins the hypnotist and others through the years."

The playground for all those new tracts back in the '60s was El Dorado Park—just the regular part, before it went regional.

"We lived right across Studebaker from El Dorado, and my girlfriends and I would chat for hours while swinging on the swings," recalls Rosemary Faulks.

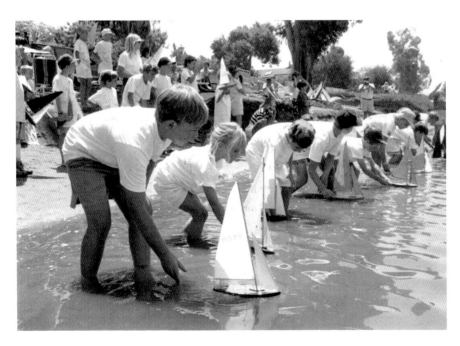

Each summer's class at the Model Boat Shop at Colorado Lagoon ended with a regatta of the new craft. *Press-Telegram.*

Randy Bellamy, now living in Chula Vista, writes, "I remember when I was little climbing to the top of the big rocket ship that stood in the park. From an adult's perspective, the rocket doesn't seem so tall, but to a little kid, getting to the top and pretending you are about to be launched to Mars was the best."

Freeman H. Welch remembers another rocket ship from back at the dawn of the Space Age. It was in "the best shoe store ever," as Welch recalls. "The Children's Bootery at the Los Altos Shopping Center. You walked in and in the back of the store was a spaceship that, after your feet were measured, you were allowed to play in."

Karen Bawden Perry remembers a different feature of the modern days of the '60s: the first time she saw a car wash—the Los Altos Car Wash on Stearns Street just west of the Los Altos Shopping Center.

John Archie recalls learning the mariner's art in model sailboat classes at Colorado Lagoon and sabot sailing lessons in Alamitos Bay in the 1960s.

"When it opened for business, my father, Phil Bawden, was mystified. He sat there and watched the procession of cars line up and proceed through the wash. He laughed and laughed. How ridiculous that anyone would be soooo lazy they would pay to have their car washed! His comment: 'This will never last.'"

Bring Back the Old

We asked readers to pretend that we're somehow capable of making their wishes come true and to submit those places of the past that they'd like to see suddenly reappear.

Of course, the Pike and Rainbow Pier were big on most lists, but with about fifty folks writing in, with various amounts of years of memories from which to draw, just about every cherished item from Long Beach's past has been covered, and by the time we finish dealing with them all, people will likely be recalling the glorious old days when you could spend the whole day downtown shopping at Wal-Mart and Nordstrom Rack with nothing in your wallet except a few $100 bills.

Shopping, in fact, ranks high in readers' recollections of life in a younger Long Beach.

"Quigley's. 'Nuff said," said Jim Clark of the Long Beach chain of department stores in which you could buy anything from a coat to a canary. Some folks recall the store's Second Street location, while east-enders are partial to the shinier shop that anchored the Plaza shopping center on Spring Street at Palo Verde Avenue.

"Bring back Dooley's," demanded an e-mailer going by PASCYC. "If you couldn't find it at other stores, Dooley's had it." "It" might include anything from yardsticks for southpaws to what many consider to be the best hot dog ever built, never mind the cheapest, at just a dime a copy.

"Dooley's was my favorite place to go with my grandfather," wrote Stephanie Davis-Mason. "I also miss Grants Department Store and Brownie's Toy Store"—both were shopping staples in Bixby Knolls.

Summer evenings were spent around campfires in the 1960s on the north shore of Colorado Lagoon. *Press-Telegram.*

Muriel Zinser Pinkerton, whose father, Howard Zinser, owned Howard's 5-and-10 on Atlantic Avenue in North Long Beach, misses her pop's store, as well as his downtown competitors, Kress and Woolworth's.

The downtown Long Beach stores, in fact, were the readers' favorites:

"Shopping at downtown's Buffum's was an elegant occasion," remembers Cindy Carlson, who would accompany her mother to the Big City on Saturday outings back in the '50s.

"You wouldn't think of going shopping downtown without getting all dressed up," she writes.

"We rode the bus downtown to shop at Buffum's, Walker's, Kress and Woolworth's," recalls Phyllis Bannister Steiner. "The dime stores were delights of tiny trinkets and other wonders, but best of all were the vanilla cokes at the marble counters sitting on stools that spun around."

As a teenager, Steiner landed a job at Walker's, where she "tried to learn everything there. I was the Easter Bunny, I ran the elevator (getting it to stop exactly even with the floor), I wrapped gifts, worked in men's furnishing with Mr. Greeno, and worked in notions. Only the older ladies were allowed to sell perfume and jewelry."

Thousands of shoppers packed the opening of a Big A Store at 5500 Cherry Avenue on opening day in 1961. Traffic backed up a mile down Cherry. *Press-Telegram.*

One wonders if memories are being made by today's shoppers—probably they are, but things change a lot more rapidly now, so your memory doesn't have to be as stout as those of some of your older-timers (memories, in other words, ain't what they used to be). It's worth noting that CityPlace's downtown predecessor, the Long Beach Plaza, reigned over Big Town from 1982 until 1999, while Buffum's lasted from 1904 until '91.

Grocery List of 1960

Enough for now of the shops and shopping centers, movie houses, bowling alleys and restaurants of boom times. Let's rummage around in the cupboards to see what we had in our new, modern, space-age kitchens five decades or so ago.

Back in the '50s and '60s, when newspapers had so many employees they had to hire people to come up with things to keep them busy, the *Independent-Press-Telegram* conducted annual consumer analyses to find out where people were buying their groceries and what they were putting in their shopping carts.

First—and this entails leaving the house one more time, then it's back into the kitchen for good, we promise—we'll look at when and where people in Long Beach and vicinity did their shopping in 1960.

The fast answer is "on Friday at Iowa Pork Shops." Friday was shopping day for 34 percent of area grocery shoppers (it was 1960, can we agree to use the term "housewives"?), and 17 percent of them shopped at the long-defunct Iowa Pork Shops. About 29 percent shopped on Saturday; 22 percent on Thursday. Trailing Iowa Pork Shops as the favorite grocery store were Safeway (16 percent) and Vons (9 percent). Further down the list were some great stores of yesteryear, especially McCoy's, which led the list of where Long Beach families bought most of their produce (19.5 percent). Among other markets cited were Hiram's, Thriftimart, Cole's, Market Basket, Mayfair, Boys, Atlantic Farms, Jolly Jim and the pride of uptown, Ray & Eddie's.

Now, let's go to the carts. Here are the top three brands of various staples purchased in 1960 by homemakers in and around Long Beach:

A researcher checks out local buying trends at the annual *Independent-Press-Telegram* consumer survey in 1954. *Press-Telegram.*

Breakfast cereals: Kellogg's Corn Flakes (25 percent); Kellogg's Rice Krispies (9.5 percent); Nabisco Shredded Wheat (7.2 percent) (Nothing sugar-coated turned up until No. 15: Kellogg's Frosted Flakes.)

Fresh milk: Knudsen (19 percent); Golden State/Foremost (18 percent); Carnation (7.5 percent)

Fresh orange juice: Golden State (15 percent); Vons (11.5 percent); Sunnyland (8.5 percent)

White bread: Weber (30 percent); Helms (11 percent); Langendorf (9 percent)

Potato chips: Laura Scudder (49 percent); Bell Brand (38 percent); Tom Sawyer (3 percent)

Cheese: Kraft (45 percent); Velveeta (11 percent); Tillamook (5 percent)

Soft drinks: Seven-Up (36 percent); Coca-Cola (25 percent); Bubble-Up (9 percent)

Beer: Hamm's (20 percent); Olympia (11 percent); Lucky Lager (10.5 percent)

Wine: Gallo (37 percent); Manischewitz (15.5 percent); Italian Swiss Colony (9 percent)

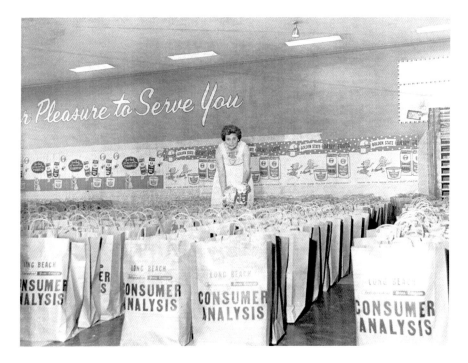

Product samples were given as incentives for housewives to take part in the annual consumer analysis survey. *Press-Telegram.*

Now, let's go down the hall, second door to the right, and see what's in the bathroom cabinet and the shower stall:

Shaving cream, pressurized can (told you this was the Space Age): Rise-Carter (20 percent); Palmolive Rapid Shave (16.5 percent); Aero Shave (10 percent)

Women's deodorant: Arrid (16 percent); Avon (14 percent); Ban (11 percent)

Men's deodorant: Mennen (19 percent); Avon (15 percent); Old Spice (11 percent)

Hair spray: Spray Net (13 percent); Satin Set (13 percent); Breck (10 percent)

Bath soap: Dial (16 percent); Lux (15 percent); Ivory (13.5 percent)

Toothpaste: Colgate (23 percent); Gleem (21.5 percent); Stripe (12 percent)

In 1960, 30 percent of households in the Long Beach–Lakewood area had an income of between $5,000 and $7,000 a year. Only 13.7 percent of households were in the power elite, hauling in $10,000 or more annually.

So, how did a poor man stand such times and live? Well, TV reception was free, for one thing (by 1960, almost every household had a TV, but only 22 percent had more than one set. The top five most popular brands: RCA, Admiral, Packard-

76

Bell, Hoffman and General Electric), and everything else was crazy cheap. Home prices were on the rise, but you could still get a new 1,452-square-foot home in College Park Estates for $22,950. More than half of the homeowners in the area lived in houses worth $12,500 to $20,000.

If you wanted to buy a fixer-upper, $15,000 would do the trick, and Norman Keith, Inc., would tile your entire kitchen (tile and labor included) for $39.50. Blue Haven would put in a fifteen-by thirty-foot pool for $1,895.

Three-quarters of the renters in Long Beach paid between $50 and $100 a month.

In 1960, 90 percent of Long Beach households dried their clothes outdoors, but housewives quickly became enamored of the new appliances, such as this Philco electric dryer. *Press-Telegram archives.*

New cars in 1960 cost as much as a severely used car in the twenty-first century. At Mel Burns Ford, you could drive home a new Falcon for $1,895. The swankier set could go to Salta's and purchase a 1960 Pontiac Catalina for $2,395.

Imports? Never heard of 'em. More than 30 percent of Long Beach–area motorists preferred Chevrolet; 27 percent liked Ford; and Plymouth was the number three brand in consumer preference. Next in the parade, in order, were Buick, Pontiac, Oldsmobile, Dodge, Mercury, Cadillac, Rambler/Nash, Studebaker, DeSoto, Chrysler and, finally, as the sole model from outside the United States, Volkswagen.

Gasoline prices you don't even want to know about. A quarter a gallon. OK, maybe that was pricey in an era when one dollar an hour was the minimum wage, but gas stations would throw in a set of commemorative tumblers, plus, in case you wondered where the term "service station" came from, they'd wash your windows, check your oil and tires, give you Blue Chip Stamps and road maps, all while you sat there like an archduke. And at the Parks Texaco station on Long Beach Boulevard and other locations

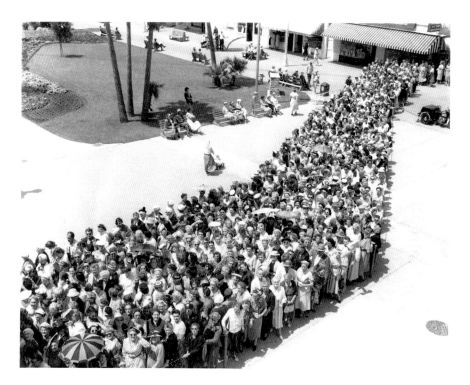

Thousands of people, mostly housewives, waited in line to attend cooking classes and see the latest appliances at the Municipal Auditorium in the 1950s and 1960s. *Press-Telegram.*

in and around Long Beach, you even got a chance to win a new Cadillac. Mobilgas was the number one choice of Long Beach–area fillers-up, with Texaco finishing in the number two spot, followed by Standard/Chevron, Shell, Union 76, Richfield and Hancock.

Women still reigned over the range in the kitchen in 1960. Electric ranges were only in 10 percent of the Long Beach–area homes then. The chances were almost one in three that if you popped into the kitchen of any home in Long Beach, you'd find an O'Keefe & Merritt gas range.

At the other end of the temperature extreme, Frigidaire was the most popular refrigerator, followed by General Electric, Coldspot, Philco and Servel.

One-third of the washing machine–equipped households sported a Kenmore in 1960, and almost 90 percent of the Long Beach–area households depended on a clothesline to dry their laundry. Of the 11 percent of homes that had automatic clothes dryers, Kenmore was again the top choice.

Here's the girdle news. Anyone who recalls just where we got off asking questions about girdles back in 1960 is now long gone, but here are the big

This ultra-modern Alpha Beta supermarket opened in 1965 on Seventh Street at Nebraska Avenue. *Press-Telegram.*

brands—actually, let's get the brassieres out of the way first: 92.5 of the respondents answered in the affirmative to the consumer analysis question, "Do you buy brassieres?" One-quarter of the bra-buyers purchased Maidenform, with Playtex, Charmode, Lovable and Warner bringing up, to employ an ill-advised term, the rear.

A slimmer number of shoppers said they bought girdles—about 68 percent. Playtex won by a ton, with more than 20 percent citing that brand. After that, it was a close race: Charmode, Warner and Silf Skin, each with about 9 percent of the total.

Grocery shopping in the 1960s could be made into a big event. Although the supermarket had become established as a one-stop shopping spot, the homemakers of forty years ago still regularly swung by two or more markets for different specialties.

"We used to go to Plowboys way down on Carson for produce and Ray & Eddie's uptown on Atlantic for meat, and we'd buy just about everything else at the Cole's Market in North Long Beach," recalled Margaret Hebert, of Long Beach, who now, she says, just buys everything at Ralphs or Vons.

Other readers have recalled some now-departed grocery stores of the era: Barbara Hauser remembered shopping at the Iowa Pork Shop grocery at Palo Verde Avenue and Stearns Street; her husband, Clarence, worked at the Thriftimart at the brand-new Los Altos Shopping Center at Stearns Street and Bellflower Boulevard.

Marineland of the Pacific

OK, it's not Long Beach, but before the dawning of the age of Long Beach's Aquarium of the Pacific, Marineland of the Pacific was the place to go to get close to the creatures of the deep.

The oceanarium was built almost as an extension of the sea itself, spread over eighty-eight acres of land atop Long Point on the Palos Verdes Peninsula.

It was the first aquatic theme park on the West Coast, built for $3 million by a New York–based securities firm that would later become Smith Barney.

When it opened on August 28, 1954, Marineland didn't even feign an interest in science or the environment. It hired a Vegas and Hollywood show producer, Frank Sennes, who put together seal-and-dolphin shows in the style of a mariner's Moulin Rouge. Dignity wasn't a term that came up a lot with those shows.

In 1964, however, Sea World opened its facility in San Diego, firing a warning shot across Marineland's bow, though the more venerable veteran barely flinched. In the first year of Sea World/Marineland coexistence, Marineland dominated with an attendance of 1.4 million to Sea World's sardine-size 400,000.

The following year, Marineland acquired the killer whale Orky, which proved to be a phenomenal draw, boosting the park's attendance to its peak of two million.

Marineland was a beautiful, fun and friendly way for Southland and tourist families to spend the day back in the '60s and '70s. It boasted an impressive one-million-gallon Sea Arena, with three underwater viewing levels for the big shows.

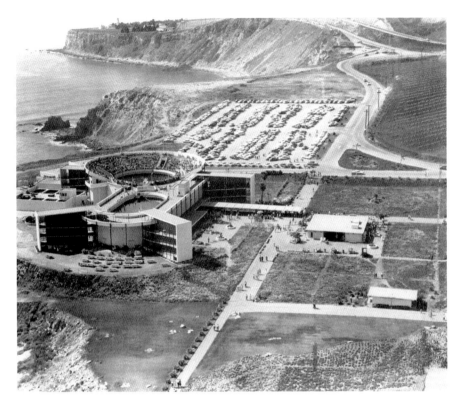

Marineland of the Pacific was a major tourist attraction on the Palos Verdes peninsula during the 1960s and 1970s. *Press-Telegram archives.*

Additionally, there were smaller tanks for porpoises, seals and walruses. Also scattered around the grounds were gift shops, restaurants, a three-hundred-foot space needle and the oxymoronic habitat that was the Penguin/Flamingo Pool.

At its apex in popularity, shortly after the arrival of Orky, it was the number two tourist attraction in the Southland, trailing only Disneyland, which debuted one year after Marineland opened.

And yet, even as early as 1967, it was becoming apparent that there was one too many fish in the Southern California aquapark sea. Sea World had caught on big time and had siphoned off a sizable portion of Marineland's potential visitors.

In 1968, Sea World outdrew Marineland by almost 500,000 visitors, an assault that Marineland countered by throwing $2.5 million in improvements into the park, including the construction of a tank for a man-eating shark in 1969.

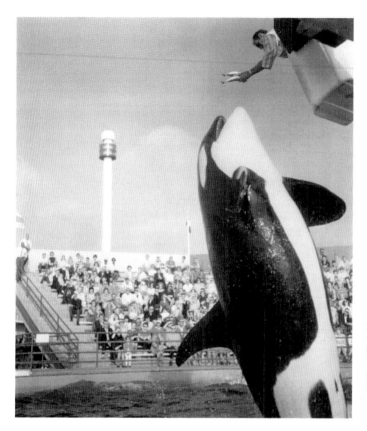

Orky, a seven-thousand-pound killer whale, was Marineland's star attraction, bringing two million people to the park in 1965. *Press-Telegram archives.*

But its glory days were fading into the past, and Marineland was flopping around on the deck. From 1968 until its eventual closure, its earnings were on a southbound slide.

It went through a string of owners over the next couple decades, including Hollywood Park, Twentieth Century Fox (which brought in disastermeister Irwin Allen to jazz things up) and Hanna-Barbera (which mixed metaphors by bringing in Yogi Bear as Marineland's Mickey Mouse).

Marineland's demise came suddenly and somewhat sordidly in 1987. The publishing company Harcourt Brace Jovanovich, which already owned Sea World, bought Marineland in early '87, promising to throw money into improving the Palos Verdes park. Instead, under cover of night on an early morning in January, the owners had Marineland's biggest draws, the killer whales Orky and his sidekick, Corky, moved down to Sea World.

Less than a month later, Harcourt's CEO, William Jovanovich, abruptly closed Marineland and fired its three hundred employees.

Movies by Car

We don't go to movie theaters. It's one of our "things" that makes us so endearing to normal people. The last movie we saw at a theater was 1997's *Good Burger* because our nine-year-old son wanted to see it. Plus, you really need to experience *Good Burger* on the big screen.

There are literally countless (though the actual number is probably closer to seven) reasons we won't go into movie theaters, and these range from the fact that invariably a guy wearing a stovepipe hat will sit in front of us to the similar reason that a movie theater is a darned good place to catch polio.

You know what would make us go out to see a movie again? The return of drive-in movie theaters. There are plenty of reasons why drive-in theaters, which are, for all practical purposes, extinct (there are a couple still alive, but they refuse to mate), are great places to see a movie, and five of the key ones were enumerated in a full-page ad in the *Press-Telegram* when the Circle Drive-In opened in 1951:

- Enjoy smoking
- Perfect for shut-ins
- No baby-sitter problem
- Enjoy complete privacy
- Be flu- and polio-protected

They had the whole page. They could have added more. At the drive-in, you can wear a stovepipe hat, split a six-pack of beer, eat a bucket of chicken and express your irritation by honking your horn at everyone from

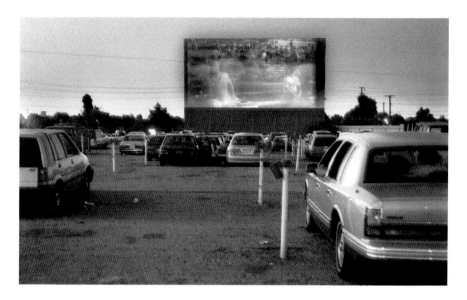

The Los Altos Drive-In Theater was one of several Long Beach drive-ins that were huge in the 1960s. It lasted from 1955 to 1996. *Press-Telegram.*

the projectionist to the film's villain to the moron arriving late and driving around with his high beams on.

Here are three drive-in memories we have. We actually have more, but you don't want to read about those:

1963: Our parents took our sister and us to a screening of *The Ugly American* at the Los Altos Drive-In, back when it only had one screen. Didn't understand one single thing. We skipped over in our pajamas to the play area and swung on the swings, went back to the car and fell asleep.

1972: We had a date with a Wilson girl, and we wanted to take her to the drive-in (duh). Problem was, we didn't have a car because we didn't have a driver's license. Our friend's parents were in Hawaii, so he generously let us use their motorhome. We picked up our date. Her dad answered the door. The cold-hearted man let us take his daughter off in a Winnebago.

1975: Twenty years old and living at home. Needed to get out. Grabbed a couple of Olympias out of the folks' fridge, swung by Popeye's for a box of chicken, stopped at a 7-Eleven for a pack of Benson & Hedges and caught a flick at the Circle.

In terms of quality movie-viewing, drive-in theaters were about a C-minus. The pig-iron speakers that you hung on your window had the fidelity of a

soup can, and light pollution rendered dark scenes invisible. But what a small price to play for not getting polio.

In a recent column asking readers what they missed most about things that are gone in Long Beach, drive-in movie theaters were frequently cited. For all the cultural memories they evoke now, they weren't around all that long—maybe two generations. The oldest in Long Beach was the Lakewood Drive-In, which opened out in the middle of nowhere on Carson Street in 1948. There's a Del Taco and Carl's Jr. there now.

Next came the Circle Drive-In on Ximeno Avenue off the Traffic Circle. It opened in 1951. Now there are some offices and a fitness club there.

The Long Beach Drive-In on Santa Fe at the Long Beach Freeway opened in 1955. There's a parking lot there now.

The mighty Los Altos Drive-In opened in 1955 with an unreeling of *Son of Sinbad* and *Rage at Dawn*. In 1972, the Los Altos became a Drive-In-Plex with three screens, with three lots capable of holding 1,074, 938 and 789 cars. There's a Kmart there now and a car dealership.

They went down when real estate went up. The Long Beach Drive-In was the first domino to tip over, closing in 1979. Then the Circle fell in '85, Lakewood in '89 and our beloved Los Altos in 1996.

Do we miss them? Well, we have great memories of them, but we're pretty sure we'd never go back, and we're pretty sure, too, not many other people would go either. There's video on demand, streaming Netflix, Blu-ray discs, polio vaccines—and since when did shut-ins ever go out to drive-ins?

Our Vinylest Hours

Out in the garage we have more vinyl record albums than we can count, and Lord knows what kind of shape they're in. We visit them once in awhile when we're brave enough to tunnel back there.

Back before the CD era, when the vinyl records were still allowed in the house, they took up entire rooms. Moving them from place to place was an all-day job.

Every one of them has a story, and most of the stories—aside from the promo copies that just slid onto our desk with no history at all—have to do with growing up in Long Beach.

We started on the youngish side. We bought Gary Lewis & the Playboys' *This Diamond Ring* when we were ten years old, and we most likely bought it at the Musical Jewel Box in the then-young Los Altos Shopping Center. That's where, for years, we picked up 45s at a buck a throw, and every week we picked up the latest copy of the 93/KHJ-AM Boss 30 Hits to check off how many—or how few—we were missing in our collection.

When our wealth would occasionally spike to dizzying heights—usually after a visit from our granddad, or whatever birthday money we could salvage after our mom took it to put toward our "college education"—we could afford an entire album at the Jewel Box, including the Doors' self-titled debut album and *Turn, Turn, Turn* by the Byrds (our copy still has a 93/KHJ sticker on the sleeve, and we're sure the record is unplayable now, having not fared well over our treatment of vinyl during our youth, which maltreatment included taping quarters to the tone arm so the over-worn needle wouldn't skip so much).

The Musical Jewel Box obviously wasn't the only game in town for the record-buyer—not even in the shopping center. The groovy basement of The Broadway (which housed the ultra-modern Ticketron machine that dispensed tickets to rock concerts, including the epic 1972 Rolling Stones/Stevie Wonder tour, for which we camped outside The Broadway waiting for the doors to open) had the latest in stereo gear, as well as some overpriced LPs.

The JCPenney store also stocked albums, though we don't recall ever purchasing any there. Oddly, the Singer Sewing Machine Shop on the Target (then Unimart) section of the center sold a small rack's worth of records.

Then there were the dedicated record stores—places where you couldn't also buy bangles, groceries or sewing machines—most notably, for us, the venerable Platterpus Records on Seventh Street, just west of Pacific Coast Highway. We cannot tell you how many albums we bought in that shop during the 1970s at $2.98 a copy, until the label greedheads knocked it up to $3.98.

We trusted the staff of the place with our musical soul, buying everything the guys suggested (we remember one of them was named Donald Sutherland), including the early works of Little Feat, Neil Young and the Grateful Dead.

There were also some short-lived shops that had cool stuff for a while, like Jeremiah McCain's in Belmont Shore, where we bought a lot of the early Americana stuff that was right in our wheelhouse, and Mundae Records on the Belmont Pier, where we biked on January 17, 1974, to buy two albums released that day: Dylan and the Band's *Planet Waves* and Joni Mitchell's *Court and Spark*.

Those record-buyers as avid as we were will report that there are some places we forgot to mention, and that's mostly because we didn't shop at those places as much.

We didn't make forays as far afield as Downey, home of Wenzel's and Middle Earth, and rarely even made it up to Lakewood to the world-famous Wallichs Music City, which we recall mostly as a place where the staff didn't mind if you played the musical instruments there—including the modern new synthesizers. Nor did we make it downtown too often, though we spent a buck or two at the extant Bagatelle, then on Fourth Street, and Licorice Pizza on Fifth.

Dirt Band and Beatniks

Occasionally, we receive missives from readers that send us on a merry chase to clarify or at least shore up our recollections of those years of our youth in Big Town.

One was from a phoner who'd just bought the thirtieth anniversary digitally remastered version of the bluegrass classic "Will the Circle Be Unbroken," by the Nitty Gritty Dirt Band and a cast of hundreds of guests. Phoner wanted to know if it's true that the Dirt Band once lived in Long Beach.

We used to walk to school back in the mid-'60s within the sound of the band's garage rehearsals. We even scored a few of their stickers for our book bag. We're not sure whose house it was, but our walking route took us up Knoxville Avenue north of Stearns Street and east of Palo Verde Avenue.

Original members Jim Fadden (drums) and Ralph Barr (vocals, guitar) lived in Long Beach when the band was formed. Those fellows were frequent visitors to the beloved and sorrowfully long-gone McCabe's Guitar Shop, where they would jam with fellow Dirt Band originals Jeff Hanna, of Seal Beach, and Jackson Browne (fresh out of Sunny Hills High School in Fullerton).

Author, journalist and beatnikologist Brian Chidester, in the course of researching a book on the beat generation, came looking for information on the early days of jazz and folk music in Long Beach as it was practiced during the 1950s and early '60s, and he's looking for your memories to help him out.

Luckily, he wasn't necessarily seeking our memories, which are stuck pretty firmly in the hippie daze following the beatnik stuff.

Wrote Chidester, "I know Long Beach has a history with jazz music, and like most of the beach towns along the SoCal coast, Long Beach had involvement with the '50s folk music revival.

"The two clubs that I know about for sure," he wrote, "were Le Clos, at 529 E. Seaside Way, and a place called the Rainbow Sign in the Naples/Belmont Shore area. Apparently, the Rainbow Sign was a place that hosted folk music. I believe Tim Morgon may have played there a few times.

"The other interesting folk/beatnik-related event in Long Beach is the first West Coast Bob Dylan show at Wilson High, promoted by the owners of the Golden Bear in Huntington Beach."

He asked our readers for their recollections of those days.

As for our own memories, we recall Le Clos, which you could get into on South Linden Avenue as it shot downhill to Seaside Way, as nothing more than a good French restaurant. Don't remember any beatnicky stuff going on there. Later, it moved to the Lafayette and was replaced by the every-bit-as-serviceable French eatery Le Grotte.

Before the latest explosion of coffee houses in Long Beach, there was an earlier outbreak, back in the late '50s. We don't remember any of them, but old-time *Press-Telegram* restaurant and night-scene writer Tedd Thomey took a shot at the names of some of the ones in and around Long Beach in an August 31, 1959 column item.

"Gotta hand it to the owners of those coffee houses which have been popping up like mushrooms all over the Southland," he wrote. "When it comes to original names for their joints, they're w-a-a-a-y out...Caffe Antiqua in Belmont Shore, the Rainbow Sign in Naples, the Crooked Candle on E. Broadway near Bixby Park and the Rouge et Noir in Seal Beach."

If the Rainbow Sign, which had moved into an old bike shop at 5941 East Second Street in 1958, ever became a hot spot for beatniks, it wasn't because the young owners were looking for that.

"The biggest thing we have to fight is the idea that Rainbow Sign is just a hangout for the 'Beat Generation,'" twenty-three-year-old co-owner Dave Deck told the *Press-Telegram* in 1958. "That might be a little easier if anyone knew what 'Beat Generation' means. I don't know—I haven't met a Beatnik yet."

Our recollections are just a quarter of a generation or so later, when we began, as a teen in the early to mid-'70s, to hang out when we could at Bristol Bay at Cal State Long Beach.

Singer-songwriter John Prine played one of his early local shows at Cal State Long Beach's Bristol Bay. *Press-Telegram.*

"When I first started it, it was a corner of the cafeteria, just an L-shaped area in the corner and we would move some chairs around on Friday night and call it Bristol Bay," recalls Frank Shargo, who attended Cal State in the late '60s and early '70s and who now works in the Bay Area. "I would go down to the Troubadour or the Ash Grove and try to book acts for as little as I could."

A bit later, Bristol Bay became a permanent fixture and was managed by grad student Mike Curran, who had access to a bigger budget, and by '72, it was attracting such acts as Jackson Browne, John Prine, Jim Croce, Roger McGuinn, John Lee Hooker and the Credibility Gap, plus a mess of jazz artists including John Klemmer, Mose Allison, Kenny Burrell and Gabor Szabo.

Strollers Was the Scene

While waiting for readers to offer their recollections of old jazz and folk clubs in town, we began to get the feeling that we missed out on some very cool sounds at a particular Long Beach club, and we can only take solace in the fact that we weren't born when the joint was at its swingin'est, which, by all accounts, would've been right around 1953.

The name of the place was the Strollers Club, and it sat on Locust Avenue (now the Promenade) just north of Ocean Boulevard.

We've been running across mentions of the place since last fall when we were digging through the archives trying to rebuild the Beatnik scene in Long Beach during the '60s.

The jazz scene came a bit in advance of the kool-kat coffee houses, though there was plenty of overlap, and the Strollers Club was the hub of that early West Coast jazz scene, by a fairly handy margin.

There are jazz buffs who would give everything to be able to time-travel back to the spring of 1953, when the place opened not so much with jazz but with the blues great T-Bone Walker, whose "Stormy Monday" is pretty much the best blues song ever penned and played.

And your jazzy time traveler would refuse to get back into the pod (or DeLorean, or whatever they're using these days) because look what else came up on the Strollers Club bill: the boogie-woogie pianist one-man orchestra Meade "Lux" Lewis (who also played semi-regularly at a few places in Long Beach, including the Moulin Rouge, according to reader and longtime jazz fan Jim Bremner); a teaming of legendary trumpeter Maynard Ferguson

Right: Blues legend T-Bone Walker, who penned "Stormy Monday," was one of the great musicians who played at Strollers on Locust Avenue. *Publicity photo.*

Below: Cover of Chico Hamilton's 1955 album recorded during his eight-month engagement at Strollers in Long Beach. *Blue Moon Records.*

jazzcity PRESENTS **THE ORIGINAL**

CHICO HAMILTON

Featuring **Buddy Collette**
Fred Katz, Jim Hall
and **Carson Smith**

QUINTET

LIVE AT **THE STROLLERS**

FRESH SOUND RECORDS

and sax-blower Plas Johnson; blowing in straight outta Watts, tenor saxman "Big Jay" McNeely; the "swingsational trio" the Hurricanes; West Coast jazz godfather/drummer Shelly Mann; sax player and Benny Goodman alum Stan Getz; singer Dinah Washington (with returner T-Bone Walker); the vocal groups the Ink Spots and the Robins; and, perhaps most memorably, the frequent appearances of the Chico Hamilton Quintet.

Oh, and time travelers don't have to bring much money in their blast to the past, because virtually all of the shows were free: no cover, no admission and all were on Sunday afternoons, starting about 3:00 p.m. (An exception to the no-cost rule was the performance of the Ink Spots. That one set you back a buck.)

Bremner (and others) have particularly vivid recollections of the Chico Hamilton group performing at Strollers, perhaps because the memory is freshened with playings of the band's album *Chico Hamilton Quintet: Live at the Strollers*.

One reviewer of the 1955 LP hinted at perhaps faulty acoustics of the Strollers Club, writing, "Despite that locale, the sound is quite clear and clean" on the record.

Perhaps as legendary as the Strollers' performers was the club's Sunday afternoon shows' host, Alex "Sleepy" Stein, who was key to bringing hot acts to town and carried a lot of weight through his radio shows on Long Beach–based KFOX before he started KNOB in Long Beach/Signal Hill in 1954, making it the first all-jazz station on the West Coast. That was where, in 1957, Stein employed the young Chuck Niles, probably the greatest jazz DJ in history, to take on a show there.

There is so much more outside the Strollers Club in Long Beach, particularly a whole spate of performances by Shorty Rogers, including one at Wilson High. We'll let journalist Chidester wrap it up as he writes about Rogers and the whole Long Beach/West Coast scene:

"Before folk hit in the late '50s and early '60s, and before surf music hit in the mid-'60s, and before folk-rock and psychedelia hit on the Sunset Strip, the real sound of Southern California was cool jazz.

"It was awesome, and it sounds like our home when you put it on."

Folk Scene

Readers obliged when we asked about the transitional time between jazz and folk and rock in Long Beach–area clubs for author Brian Chidester's book *The Beat Generation in Los Angeles*.

We asked readers to send in their memories of the old folky days, and our favorite came from John Wilson, who was a sophomore at Wilson High (no relation) when Bob Dylan performed there on December 5, 1964.

And while Wilson, to his regret, missed the Dylan show, he immersed himself in the local folk scene at that time.

"There were several coffee houses and folk venues I remember," he writes. "The Cave on Naples Plaza was a dark little room where we seniors drank Cafe Americains (I think it was Folgers) and smoked our pipes of cherry blend and listened to Silver Dagger while sitting on old couch cushions on the floor and wondering 'Who is John Galt?'—the place was run by a bunch of rogue Existentialists; since none of us had read Ayn Rand at the time, it just added to the romance and mystery.

"That place lasted for about a year," continues Wilson. "We then moved on to the Rogue et Noir (in Seal Beach) and the Prison of Socrates (in Balboa).

"Next, we found the Merry Monk (in Long Beach at 5630 E Pacific Coast Highway), a place we have fond and hazy memories of (we had since turned 21 and discovered beer in pitchers and wine coolers), including performances by the locally legendary Crazy Danny Murphy and Reggie Bannister (of 'Phantasm' fame).

"Then, there was the Bodega on Second Street in the Shore, where you could see Steve Gillette and some other lesser known touring acts, and the People of Orphalese on Anaheim Street near Redondo Avenue."

Later still, Wilson recalls the expanded version of Mike's Munchies in Marina Pacifica, where, again, he mentions seeing Danny Murphy and Murphy's more restrained partner, John Penn. But that's getting up into the rock age and well into the '70s. We used to catch Murphy/Penn all the time at the Hindquarter in Naples during the '70s (we worked there; we had to see them), as well as at Huck Finn's in Naples and at Cal State Long Beach, including that school's annual Banjo, Fiddle and Guitar Festival, a great affair that featured such headliners over the years as Emmylou Harris, Guy Clark, Jimmy Buffett, Linda Ronstadt and many others.

Before the Lights Went Out

Long Beach is famous for more reasons than we can count (or feel like counting, anyway), and the latest reason came through our e-mail box when Lynn Hoskins, of Laguna Niguel, who does promotional work and an internationally distributed newsletter for the rock band the Electric Light Orchestra and its affiliated artists/outfits Jeff Lynne, the Move and Roy Wood, wrote: "Long-time fans overseas talk of coming to Southern California so they can have their photo taken in front of the Municipal Auditorium, where Electric Light Orchestra's *The Night the Light Went On (In Long Beach)* album was recorded back in 1974.

"And then I have to break it to them that this historic concert venue is no more.

"If you have a moment, would you mind telling me what happened to the Long Beach Auditorium so I can pass the info on to ELO fans around the world?"

What are the odds that Hoskins would catch us at that rarest of times, when we actually had a moment?

The auditorium, one of the grandest buildings to grace our stretch of the Pacific's shore, was torn down in 1974 to make room for the current Long Beach Performing Arts Center and its adjacent Convention Center.

And it was torn down with the usual giddiness and enthusiasm that the city seems to enjoy while knocking down a stately past to make room for a promising future. An editorial in the *Press-Telegram* in 1967 mirrored the city fathers' feelings regarding the old auditorium, built in 1930. "Let's face it,

One reason cited for the destruction of the Municipal Auditorium was that its architecture "clashed" with the new Long Beach Arena. *Press-Telegram Archives.*

the old Auditorium has been something of an embarrassment," wrote the editorialist. "Its architecture clashes with that of the Arena. Its structural features, while sound, are not such as to enthuse 1967 convention lookers. And its approach is difficult and unattractive."

Clashes with the arena's architecture? By all means, bring on the wrecking ball! Actually, what was perhaps more problematic for the auditorium was its skimpy size. To keep its share of the rapidly growing convention biz, Long Beach needed something a bit beefier and glitzier than the diminutive and dowdy auditorium.

In its earlier years, it played host to scores of conventions and conclaves, pageants and performances. It was the home hall for the Long Beach Municipal Band as well as a stopping spot for touring classical musicians and pop artists. On February 17, 1947, Liberace embarked on his first international tour with a kickoff show at the auditorium. Later, rock 'n' roll came to the venue. Early rock shows included performances by Elvis Presley (June 7, 1956); Ritchie Valens, with Sam Cooke and Dick Dale (January 17, 1959); and Bob Dylan (December 7, 1965).

The Electric Light Orchestra concert that was recorded for the LP *The Night the Lights Went On (In Long Beach)* was part of a big month of May during the auditorium's last spring. Other than an Elvin Bishop show—the final concert at the hall, on October 20, 1974—that May was the end of the rock era for the concert hall.

In addition to ELO's show (with opener Maggie Bell) on May 12, 1974, the month's concert lineup at the auditorium included Steely Dan, May 5; the Guess Who, with B.W. Stevenson and David Bromberg, May 18; Poco, with Fairport Convention, featuring Sandy Denny and Honk, May 24; and Savoy Brown with Manfred Mann and KISS. (The KISS show was broadcast by Long Beach radio station KNAC and shows up frequently as a bootleg called, among other things, *Fried Alive*.)

As long as we're getting all teary-eyed about some great auditorium rock shows of the past, here are some others you might have attended:

Three Dog Night (with Lee Michaels and Smokestack Lightnin'), May 30, 1969; the Band, February 6, 1970; Peter, Paul & Mary, March 20, 1970; Jerry Lee Lewis, January 9, 1971; Alice Cooper (with Black Oak Arkansas), July 11, 1971; James Gang (with Edgar Winter's White Trash and War), October 17, 1971; Arlo Guthrie and Ry Cooder, November 27, 1971; Deep Purple (with Buddy Miles and Uriah Heep), January 30, 1972; the Allman Brothers, March 5, 1972; Emerson, Lake & Palmer (with John McLaughlin & the Mahavishnu Orchestra), March 22, 1972; Humble Pie (with Sweathog), April 16, 1972; Cheech & Chong, June 16, 1972; T. Rex (with the Doobie Brothers), October 15, 1972; Quicksilver Messenger Service (with the Mark-Almond Band), February 17, 1973; Stevie Wonder, March 16, 1973; Foghat (with Tim Buckley and the Strawbs), March 2, 1974; Tower of Power (with Redbone and Journey), March 10, 1974; and Kris Kristofferson, March 17, 1974.

ELVIS! ELVIS!! ELVIS!!!

The Elvis fans are restless. When it comes to the finest rock shows in Long Beach, Elvisologist Mary Hinds ends the debate with the declaration, "THE KING performed—hands down—the best concerts ever at our sadly now-dead Municipal Auditorium and the [Arena]."

It all began on June 7, 1956, with the defibrillating rocker "Heartbreak Hotel," as the twenty-one-year-old boy who would be King swaggered to the microphone at the auditorium, his guitar strapped over his shoulder like an assault weapon.

Four thousand teenagers—the loudest ones girls—broke into their savings for the $1.50 it took to buy a ticket to Presley's first show in Long Beach. The *Press-Telegram*'s man on the scene, Paul Wallace, jotted furiously as all bobby-sox-hell broke out around him. He reported the howlings in the paper:

"Oh, rock me, baby," screamed a bobbysoxer.

"Go, go, go, honey," cried another.

"Love me, baby! Sing for me!"

Ask your mom or, by now, your grandma if people really yelled stuff like that at concerts.

The performance was Elvis at his writhingest, a near obscenity in those days when sitcom couples slept in separate beds. The undulations of the King, says Mary Hinds, "caused the William Morris Agency to bitch to Col. Parker that Elvis might consider doing less shaking in the future."

For this kind of advice, they took 15 percent.

Elvis was in full Kinghood when he returned to Long Beach, this time at the arena, for a two-show stay in 1972. He was a more mature entertainer

[01] Also Sprach Zarathustra *(1.43)*
[02] See See Rider *(2.28)*
[03] I Got A Woman *(2.25)*
[04] Until It's Time For You To Go *(2.25)*
[05] You Don't Have To Say You Love Me *(2.04)*
[06] Polk Salad Annie *(3.13)*
[07] Elvis Welcomes The Audience *(1.06)*
[08] Love Me *(2.19)*
[09] All Shook Up *(1.01)*
[10] Heartbreak Hotel *(1.41)*
[11] Blue Suede Shoes *(1.07)*
[12] The Wonder Of You *(1.37)*
[13] Teddy Bear/ Don't Be Cruel *(1.53)*
[14] Love Me Tender *(1.39)*
[15] Little Sister/ Get Back *(2.29)*
[16] Hound Dog *(2.06)*
[17] I'll Remember You *(2.35)*
[18] How Great Thou Art *(3.03)*
[19] Suspicious Minds *(4.22)*
[20] Band Introductions *(1.17)*
[21] Burning Love *(2.45)*
[22] Fever *(3.17)*
[23] You Gave Me A Mountain *(3.18)*
[24] Can't Help Falling In Love *(1.44)*
[25] Closing Vamp & Announcement *(1.31)*

*Recorded at the Long Beach Arena, CA
on November 15, 1972*

Cover from a bootleg CD of Elvis's 1972 concert in Long Beach shows the singer's set list for the show.

by then and insanely world-famous. Instead of hopping onto the stage with his guitar, he was more of a miraculous apparition, emerging through the strains of "Thus Spake Zarathustra."

His set list for the two nights ranged from his early work (again, "Heartbreak Hotel," "Blue Suede Shoes") through his more contemporary tunes ("Suspicious Minds") and even gospel ("How Great Thou Art").

Hinds recalled that Presley and his entourage flew into Long Beach Airport on his plane, the Lisa Marie, named for his daughter.

More remarkably for the two sold-out shows, little four-year-old Lisa Marie was in the arena crowd, watching her pop perform onstage for the first time in her life. You gotta know Dad put on a good show.

Not so much on his third and final visit to Long Beach, when he played the arena in 1976. Only blindly adoring Presley fans saw much to enjoy in that show, when he had grown a few sizes into ever-expanding jumpsuits. Our correspondent at that show said it was like watching "a chubby puppet wrapped in a double chin and a foreign body work through a series of Elvis songs."

He closed with a nice enough version of "Can't Help Falling in Love." And sixteen months later, he was dead.

Feast for a King

Before the SeaPort Marina Hotel became little more than a debate point, local Elvis fans may always recall it as the place where Presley cooled his heels in a second-floor suite, at what was then called the Edgewater Hyatt House, his arms flanking a platter of room-service breakfast on the morning between his twin sold-out sets at the Long Beach Arena on November 14 and 15, 1972.

We know what that groaning platter held as Elvis Presley went at it with utensils a-flying, because the night bellman sang like a little bird when the *Press-Telegram* asked him to dish the dirt on the idol's doings at the marina-adjacent inn at 6400 Pacific Coast Highway years ago.

The King's breakfast, as ordered by one of his black-belt aides: three halved honeydew melons, a four-egg omelet and six side orders of bacon.

His dinner was entirely bacon-free but still made great use of the killing floor as it was anchored by a chicken-fried steak and a New York steak with asparagus and green beans presumably thrown in so that he wouldn't keel over right there at the room-service pushcart.

The beleaguered room-server was not allowed in to see Presley himself. Rather, according to the *Press-Telegram*, an aide would poke at the food and, when the waiter asked if everything was all right, the aide replied only with "a pit-pat of mock applause."

Ah, the slow clap. Has there ever been a cooler expression of sneering bogus enthusiasm?

The security during this, the second of Elvis's three Long Beach swing-throughs, was pretty intense. Presley and his entourage took over an entire section of the hotel, booking rooms 160 through 299.

To get from the parking lot to the King, you'd have to flash your hotel or Official Elvis credentials at a barricade manned by moonlighting LBPD officers, then run a gauntlet of "large men milling outside his door."

From nearby rooms, it was reported, "more policemen peered through partly opened doors, checking any possible movement," while in still other rooms in the vicinity of the Guarded One, his personal bodyguards—"reputedly all black-belts in karate—were ready to check on anyone who might have gotten through all the layers of security."

Was all of this necessary? Probably not. Elvis was thirty-seven when he hit Long Beach in 1972, and while he was still a big hit with the ladies, the ladies also tended to be into their thirties and beyond. The teenybopper days of tearing Presley to pieces out of sheer adolescent freakiness had turned into a sort of doe-eyed hankering for the hip-shaking rebel and rebellion of their youth.

Which isn't to say the magic wasn't there; it's just that it was magic with nostalgic overtones.

The set lists were virtually identical both nights, as was Presley's attire (he wore a silver cap and gigantic gold belt both nights, with a Tiffany suit on the fourteenth and a Saturn suit on the fifteenth). Both nights opened over the top with the strains of "Thus Spake Zarathustra" and both closed nicely with "Can't Help Falling in Love."

In between was a career-spanning set that included "Hound Dog," "Blue Suede Shoes," "Suspicious Minds," "Heartbreak Hotel," "Little Sister" and "How Great Thou Art."

Meanwhile, back at the hotel, Presley and his thugs, all fat on the King's royalties and slabs of chicken-fried steaks, packed up after the Long Beach concerts and headed for some shows in Hawaii, leaving the rooms all disheveled and finally accessible to fans.

Shortly after their departure, according to an Edgewater bellman quoted in the hometown paper, "some of Elvis' matronly fans slipped into his suite. They clutched his soiled sheets and stained pillowcases to their breasts and sighed."

And, we like to imagine, they swayed, standing in place out in the autumn night at the hotel, the moonlight sparkling like garish jumpsuit sequins on the water between the yachts creaking in their marina slips, sweetly humming the lyrics to "Love Me Tender."

High overhead a plane sped silently, wingtips twinkling with rubies and emeralds, toward Oahu and the next hotel.

The Fans Still Remember (Sigh)

Elvis came to town in a black Cadillac convertible. The date was June 7, 1956, years before he would become the King who liked his Caddies pink.

Inside Long Beach's Municipal Auditorium, bobbysoxers and sneering boys shrieked and stomped and waited to get their $1.50's worth—that was the price for general admission; $0.50 more got you a reserved seat.

The shrieking reached painful levels as the twenty-one-year-old star swaggered onto the stage, a guitar strapped over his shoulder. Wearing a lavender sport jacket over an ivory shirt opened at the collar, and charcoal slacks cascading over his shoes, Elvis mumbled a few words into the microphone.

The words are lost to time, if they were ever heard at all over the din of adulation, and then Presley launched into the first number, a song that's already held up over the span of almost half a century and still has as much punch and power as any song in rock history: "Heartbreak Hotel."

Using a microphone stand a good two feet taller than he was, Elvis would snatch the stand violently and pull it down and sing into the mike: "Blue Suede Shoes," "I've Got a Woman." He gave the crowd—forever screeching and surging toward the stage before being repelled by a private police force—all it could handle in just thirty minutes.

The June 7 show was the first of four Elvis Presley concerts in Long Beach, and it rocked a town that was still largely lazy with retirees from the heartland who preferred the usual auditorium fare of Municipal Band concerts and symphonic orchestras.

It was also an era when the bar for obscenity was set very low to the ground. One Canadian music critic, after Elvis had played a date in Vancouver, wrote darkly of a performance that "had not even the quality of a true obscenity; merely an artificial and unhealthy exploitation of the enthusiasm of a youth's body and mind."

Long Beacher Sandra (Gasper) Bennington was a thirteen-year-old shrieking fan of Elvis and was one of the lucky ones to see him at the '56 Long Beach show, which she attended with her mother and her best friend.

"We didn't have good seats, so my friend Dorothy and I went down closer to the stage," she recalls vividly. "During the show, Elvis walked to the edge of the stage and winked at me. I thought I would die! He gave a great performance and changed my life forever. My mom liked the show too, but she commented to me, 'He sings good, but does he have to shake so much?'"

"I remember going to Grandma's house to see Elvis on *The Ed Sullivan Show*," recalls Maridonn Ventris, who grew up in Long Beach.

"I didn't know what he looked like, but I had fallen in love with his voice the moment I heard him sing for the first time. It was 'Heartbreak Hotel.' And when I finally saw him on TV, gosh, what can I say? He was this mysterious mixture—very sexy and forbidden, yet we were told he was a Christian, and he loved his mother. He was a mix between wholesome and dangerous."

Presley was considerably more accepted by a greater chunk of the public by 1972, when he returned to Long Beach to play a pair of dates, November 14 and 15, at the Long Beach Arena.

Ventris made it to the November 15 show, saying, "It was wonderful. I remember looking around and seeing people a lot younger than I was, screaming, and I thought how wonderful it was that the magic was still around for people who hadn't even been born when he started."

The '72 show was the only time Ventris saw Presley perform live, and she says, "It was like being in the presence of someone who had fulfilled his destiny. Even though I was in the nosebleed section, the enormity of his contribution struck me at that time."

"In life," says Ventris, "you usually get over everything, but I will never get over Elvis."

Food provided Long Beacher Rosemary Danon entry into the arena for the show.

"I was fifteen years old and working at the arena selling hot dogs for the sole purpose of getting in free to concerts," she says.

"I wasn't particularly interested in seeing Elvis, but when I wandered out to see the show, I was spellbound. The man rocked. When Elvis sang he was

dramatic, passionate and sexy. But when he smiled, there was magic. And even today, when I hear an Elvis song, I can still see him smile and then I remember the magic."

Presley, by '72, had pretty much gobbled up every definition of the word "huge." He had ballooned in size, but he was still packing arenas with adoring fans. In Long Beach, he had sold out the arena both nights—a tad over fourteen thousand for each performance.

For those who like their Elvis in leather and in his thinner, more rebellious rock role, the show was less than spectacular.

"It was a sham," recalls Terry Smith. "I saw Elvis in August of 1969 when he made his comeback at the International in Vegas, and he was absolutely unbelievable then.

"But when we saw him again at Long Beach in '72, he was horrible. The show lasted less than an hour, he'd got into the jumpsuits and sequins, and it turned a bunch of us off who'd been there from the beginning."

Ouida King, who lived in Long Beach most of her life before moving to Hesperia, disagrees, mostly. "In '72, I said, OK, he's going for a new look. I didn't personally care for it, but he was fabulous, even when he was bad. No one, still, to this day, can say anything bad about him."

Presley took one last swing through Long Beach sixteen months before his death. He played, once again to a sell-out crowd at the arena, on April 25, 1976, relying on a mix of patriotic, gospel and rock tunes.

Press-Telegram rock critic Denise Kusel wrote that, by that time, Presley had ballooned to the point that "it was like watching a chubby puppet wrapped in a double chin and a foreign body work through a series of Elvis songs," and when Elvis sang the opening line of the Sinatra standard "My Way"—"And now, the end is near"—it was like hearing "a chilling prophecy."

Linda MacRill, a lifelong Elvis fan, was quoted in a teen reader survey about whether Presley was washed up. And this was in 1957, when he'd only just begun: "Most of the chicks in my crowd still love him as much as ever," responded MacRill (then Mulhall), at thirteen.

MacRill saw Presley at both ends of his career, in 1957 at the Pan Pacific in L.A. and in '76 in Long Beach. "The '76 show was different," she says diplomatically.

"I didn't care that he had slowed down," she says. "I just have always loved his music, and I still listen to him a lot."

Ouida King was also at the '76 show in Long Beach. "I was at the '72 show as well—the November 15 one—and I think I liked the '76 show better. At least I had better seats for the '76 show. By then, he was slowing

down. He didn't have the energy that he'd had in previous performances. And he perspired a lot, but I didn't care. It just meant more scarves to wipe off the sweat."

Maridonn Ventris didn't care either. She's just glad to have shared the planet with the King. "One of the highlights of my life was living when he hit it big and to have lived along with him throughout his life.

"He closed every concert I saw with 'Can't Help Falling in Love,' and I always loved that line from the song, 'Some things are meant to be.'

"That was Elvis," she says. "Elvis was meant to be."

Naked Rock, Briefly

The bar for provocative posing onstage ratcheted up briskly in the rock years following Elvis the Pelvis.

Reader Anthony Chaffins remembers seeing the Doors, probably in 1970, at the auditorium. "Jim Morrison wore tight-fitting leather pants. He grabbed his privates a lot. It was quite a performance. Very graphic onstage."

Chris Edinger of Long Beach fondly recalls seeing the Red Hot Chili Peppers at Fender's Ballroom in the mid-1980s. "When they came out for an encore they were just wearing socks over their genitals. The whole place just went wild, all screaming and yelling. It was a weird and amazing sight."

And Jodie Hawkins leaves us wanting more with her memory of "the little-known band Jaguar," who she saw "probably in the early to mid-'80s.

"The concert was 'memorable' because the lead singer opted to do the last part of the concert in the nude!" writes Hawkins. "It WAS going to be a lot of fun when I got to testify at the trial (you don't really need to know why I was on the witness list), but the band wimped out, pleaded guilty, took their clothes and left town."

Rocking in the '60s

Depending on your point of view, Long Beach in the 1960s was either the birthplace of rock-and-roll or the city where rock-and-roll went to die.

From the natal angle, perhaps the town's most notable achievement in the '60s chapter of rock-and-roll history was in providing the stage for the first live performance of the Hawthorne-based Beach Boys.

The clean-cut pioneers of the California surf sound played a twenty-minute set on New Year's Eve in 1961 as part of a memorial concert for Ritchie Valens at the Long Beach Municipal Auditorium. They were paid $300 for the gig. (Valens, in fact, headlined an all-star slate that included Dick Dale and Sam Cooke at the Municipal Auditorium on January 17, 1959.)

The seminal hard-art, pre-punk rockers the Doors didn't exactly launch their careers in Long Beach, but they enjoyed their first big payday with a pair of concerts (at 7:30 and 10:00 p.m.; Canned Heat was the opener) on December 1, 1967, in the Men's Gymnasium at Cal State Long Beach.

The Doors scored a cool $10,000 for the evening thanks to the hard negotiating by the group's new promoter, Rich Linnell. The Doors would return to town three years later at the top of their game, playing a February 7, 1970 show at the Long Beach Arena.

Then there was the homegrown Nitty Gritty Dirt Band, whose members used to hang out regularly in 1965 at the now-defunct McCabe's Guitar Shop on Anaheim Street, near Wilson High School.

In the band's early years, its roster included Jackson Browne. Browne, who, of course, later became a superstar and kingpin of the songwriterly

L.A. sound, wrote several tunes for the Dirt Band, including a rather horrid and decidedly uncivil tune called "It's Been Raining Here in Long Beach," which concluded with the verse:

> *Once upon a time I was a kid*
> *but now my hair is turning gray*
> *I'm getting fatter every day*
> *If you've got any sense you'll stay away*
> *And never give another thought to Long Beach*

Multi-string man John McEuen, who took the Dirt Band on to greater fame over the next twenty-five years, replaced Browne.

Just at the time the Nitty Gritty Dirt Band was forming, America's great new troubadour Bob Dylan passed through town, where he played a now-legendary folk set at the Wilson High School Auditorium on December 5, 1964. Dylan returned a bit more famous a year later, when he electrified the crowd at a December 7, 1965 concert at the auditorium.

But, just as Long Beach caught its share of rockers on the rise, it was also a swan song setting for some acts that closed out their careers in town. Most notable of these was Buffalo Springfield, a band that was so packed with talent and would-be bandleaders that it spent almost its entire life in a bickering, breaking-up attitude. It finally all came apart in the band's final performance, held May 5, 1968, at the Long Beach Arena. Sharing the bill with Country Joe & the Fish, Canned Heat, the Hook and Smokestack Lightnin', the Springfield played most of its considerable batch of hits during the show, including "Mr. Soul," "For What It's Worth" and the show/career closer "Bluebird."

Another supergroup, Cream, performed one of its final shows in Long Beach. Guitarist Eric Clapton, drummer Ginger Baker and bassist Jack Bruce rocked the arena on May 28, 1968.

When it comes to superlatives in Long Beach's history of '60s rock, our favorite one is Most Frightening, which is the honor Rolling Stones guitarist Keith Richards bestowed on Big Town when his band performed at the Arena on May 16, 1965.

The band, performing with the Byrds, played an afternoon set that included Chuck Berry's "Around and Around" and the Stones hits "Little Red Rooster" and "The Last Time."

The post-concert plan was to whisk the Brits through the arena's back halls and into a waiting Mercury station wagon, which would drive them out near

the Pike to a waiting helicopter. Word had leaked out, though, and when Mick Jagger and his band mates reached the car, hundreds of screaming girls were there, and the wagon was swamped by fans who climbed all over the vehicle. After they were finally cleared off by local cops, the Stones fans showered the car with (according to the next day's *Press-Telegram*) "cosmetics, shoes, purses, wallets, lipsticks, bottles and even some underclothing."

By the time Jagger and Co. reached the chopper, the car's front lights had been broken out, the luggage rack torn off and its cargo scared out of its wits.

Later, guitarist Richards would describe the scene: "Without exaggeration there must have been a hundred piled on top of the car, and we could hear the roof creaking and cracking. Inside, panicking like mad, we stood up and tried to hold up the roof. But the kids were everywhere: outside, trying to force the door handles, trying to smash in the windows. We couldn't get moving, otherwise someone would have been killed. It was definitely the most frightening thing of my whole life."

'70s Arena Rock

You want to get a bunch of former "hope I die before I get old" boomers all weepy-eyed with nostalgia? Steer the conversation over to arena rock in the 1970s.

In those days, nightclubs were OK, but the major talent was found in the eardrum-crushing, ten-thousand-plus venues, and locally, the biggest house in town, and the one that played host to some of the country's greatest rockers in the '70s, was the Long Beach Arena.

"What a great time to be in our 20s," recalls Craig Miller of Long Beach. "The first concert I saw at the Arena was the Moody Blues and the Steve Miller Blues Band. Steve Miller was soooooo loud it was like a giant hand holding me down in the seat."

Katy Simone of Long Beach was among the thousands of us who recall the legendary 1971 (oft-bootlegged) arena concert by the Who.

"I'll never forget that concert because [guitarist] Pete Townshend was on one big ego trip (as he should be!)," she says.

"He was wearing a crown and telling the audience he was the king of rock & roll, when someone in the crowd snatched the crown from him…He yelled—and I mean yelled—'I am the King and someone has my crown! Give me back my crown!' This went on for what seemed like a good half hour."

At last, the crown ended back on King Pete's mammoth head, and says Simone, "Other than the crown incident, the concert was fabulous. It was when 'Tommy' and 'Who's Next' were popular. The live performance was perfect and the Arena was filled to maximum capacity. Those were the days!"

The Long Beach Arena hosted scores of the biggest rock acts of the 1960s and 1970s. *Long Beach Convention & Visitors Bureau.*

Plaza-area realtor Bob Slawson remembers seeing an odd hard-rockin' triple-bill at the arena in January 1975 that featured KISS as an opener for Wishbone Ash, with Camel playing at the bottom of the bill.

"At the time I didn't know who KISS was," he says. "I actually liked Wishbone Ash and Camel—still do like Camel. I've just always remembered it as a strange combination of acts."

Isabella Carlson of Seal Beach was into the more classically tinged tunes of the bands Yes and Jethro Tull in the late '70s.

"I saw both bands a total of five times at the Arena in 1979," she recalls. "Yes played in the round, on a rotating circular stage, two nights in a row in May [25 and 26]; and Tull played three straight nights in November [13–15]. Every single show was absolutely breathtaking, I have very vivid and happy memories of those nights in Long Beach."

And there was so much more during the late '70s in Long Beach's chapter in rock. The years 1977 through '79 were incredibly busy times for the arena. In '77, more than thirty bands visited the venue, including Lynyrd Skynyrd; Santana (with Van Halen opening); Foghat; Boston; Emerson, Lake & Palmer (following a set by Journey); the Commodores; the J. Geils Band; Robin Trower (with Eddie Money on the undercard); Blue Oyster Cult; Queen; and a double bill of Kansas with Cheap Trick.

In '78, some notable acts came to Long Beach to play not only the arena but also the classy Terrace, which welcomed on its stage that year the Grateful Dead's Bob Weir and his band, plus Peter Gabriel, Jackson Browne, Al Green, Robert Palmer and Van Morrison, while in the big house you might've seen Parliament-Funkadelic, Journey, the Outlaws, Styx, Andy Gibb, Aerosmith (with AC/DC opening), Ted Nugent, Jethro Tull, Sammy Hagar and a New Year's Eve show with Cheap Trick.

The Terrace got out of the rowdy rock business (despite the relative tameness of its '78 shows) in 1979, offering instead concerts by the Manhattan Transfer and a three-night stand by the Mills Bros.

The arena continued to pound out the hits, however, with two nights by the emerging Elvis Costello (February 13–14), plus the already-discussed two nights by Yes and three by Jethro Tull.

The decade's final shows were September '79 concerts by AC/DC and REO Speedwagon; November visits by Rainbow, Santana and a twin-billing of Waylon Jennings and John Prine; and December programs by Blue Oyster Cult, Cheap Trick and a December 31 decade-closer by Devo.

Rock of Our Ages

Maybe it's the color of our hair, but for some reason, people like to come up to us and start talking about the old days of rock-and-roll. Not the goofy, '50s old days, but the much, much better days of the late '60s and early '70s.

"Remember [Jethro] Tull back in '71 when they played the Long Beach Arena and they had that riot?" said a recent caller, sounding like Chris Farley hosting a public-access show. "That was cool."

"Plus, remember the Dead at the Arena, also in '71? Garcia played 'Dark Star' and they opened with 'Box of Rain'?"

We probably wouldn't remember all that if we weren't surrounded by scraps of paper, news clips and Web access that tells us that the Jethro Tull fracas wasn't really a riot, but a lot of people were busted, and it came on April 19, 1970, when Ian Andersen led his five-piece band through some of our favorites of the group—"Nothing Is Easy," "My God" and "With You There to Help Me."

We saw Tull a few times at the arena, but we missed the '70 big-bust show, when forty-four people were arrested by the Long Beach PD for (it says here) "drugs."

Two arrests were not drug-related—one was for resisting arrest, the other for merely being drunk.

One girl, according to no less a source than your April 20, 1970 *Press-Telegram*, "squeezed into the space under the stage where police said her frantic gyrations wedged her between the stage support beams...she

managed to wriggle out of all her clothes before fainting as the last twang of a Jethro Tull number echoed off the Arena walls."

The uncredited reporter apparently thought Jethro Tull was of the Homer and Jethro variety. Tull, we certainly recall, did not "twang."

The concert was a sort of changing-of-the-guard show, as just two days earlier, in front of what we are guessing was a nice and polite crowd, the arena hosted a revue that included Chuck Berry, Bo Diddley, the Drifters, the Coasters, the Shirelles and Bill Haley & the Comets.

Still, the one-bad-egg thing held in this case. Rock-and-roll was banned from the arena and the adjacent auditorium throughout the summer, with the exception of the too-late-to-cancel Sly & the Family Stone show, with opening act Mountain, at the arena in May. Ten people were arrested on "assorted charges."

As for the Grateful Dead, despite the claims of our fan of its '71 show at the arena (though, again, no; it was December 15, 1972, after the ban, though the Dead itself would be banned from Big Town after a string of 1988 shows here that had Pine Avenue and Ocean Boulevard and other places thereabout crawling with sinisterly peaceful Deadheads for a week), the band didn't open the show in question with "Box of Rain," though it did perform it later in the evening, and there are few, if any, songs that the band had more trouble performing than "Box of Rain." Don't believe us? You can listen to the whole December 15, 1972 Long Beach Arena show—and virtually every Grateful Dead show ever—on the Web at www.archive.org.

The concert that night was a pretty good one (we were there, but we also listened to it recently to, you know, refresh our memory), including Garcia's better-than-usual reading of "Dark Star."

The show's opening number—and we're sort of coming full circle here—was Bob Weir's version of Chuck Berry's "The Promised Land."

Arrests were probably made, but we could find no record of it.

Long Beach Playlist

Remember these shows? All these tunes are from albums—only a couple that are unauthorized but widely available if you know your way through the dark underworld of the Web.

1. "'Round Midnight," Joe Pass (from *Blues Dues: Live at Long Beach City College*)
2. "Stormy Monday Blues," Bobby "Blue" Bland (from *Long Beach 1983*)
3. "Daytripper," Electric Light Orchestra (from *The Night the Light Went Out (In Long Beach)*)
4. "Won't Get Fooled Again," the Who (from the bootleg *Closer to the Queen Mary*)
5. "Smoke on the Water," Deep Purple (from *Live in California Long Beach*)
6. "Love Like Winter," A.F.I. (from *I Heard a Voice: Live from the Long Beach Arena*)
7. "More Than a Feeling," Boston (at the Long Beach Arena, 1977, various bootlegs)
8. "Since I've Been Loving You," Led Zeppelin (live at the Long Beach Arena in 1972, from *How the West Was Won*)
9. "Powerslave," Iron Maiden (from *Live After Death*, Long Beach Arena, 1985)
10. "Stranger in a Strange Land," Leon Russell (from *Leon Live*, recorded in the Long Beach Arena, 1972)

More Memories of Arena Rock

On December 10, 1971, we got a call from our friend Richard, who told us to put on some black slacks, a white shirt and a bow tie, and he could get us into the Who concert that evening at the Long Beach Arena. We were told to go to the back entrance and tell the guy at the door that we work in concessions.

"The arena is round," we said to Richard. "How can you tell where the back is?"

"It's at the opposite end of the front," he explained. "Oh, and you have to be there at 4:00."

"But it's a 7:30 show," we said.

"Do you want to go or not?" he yelled. "I can call someone else."

So we did as we were told (after first going to our dad to get a night's hiatus from restriction for some imagined slight; if we'd asked our mom, who doubtlessly put us on restriction in the first place, we'd have gone 0-for-Who that evening) and, along with our black-slacked and bow-tied friend Jeff, saw the Who in one of the most historic nights of rock at the Long Beach Arena.

It was a show in support of the band's then-new *Who's Next* LP, which we're pretty sure is the band's best record, and the show featured Pete Townshend famously screaming a diatribe at the crowd that would later be the kickoff track for the band's box set, *Thirty Years of Maximum R&B*.

And we're not even sure if that's the best concert we ever attended at the arena, which opened on October 4, 1962.

The hall, which coexisted for a few years with its next-door neighbor, the Municipal Auditorium, turned fifty in 2012, making that day a good time for us to reflect on the hall's greatest hits. We published, in our column, a year-by-year best-of of the decade to help rattle the brains of rock fans of the era:

- 1969 (bonus year): Creedence Clearwater Revival, Simon & Garfunkel, Three Dog Night
- 1970: The Doors, the Moody Blues (with the Steve Miller Band and Poco), Jethro Tull
- 1971: Deep Purple (with opening act Rod Stewart, before he was sexy, and again, we had to dress like a monkey and get there early), the Who, Alice Cooper, Black Sabbath
- 1972, Your Year of Years: The Allman Brothers Band (with, if our memory hasn't abandoned us, the Marshall Tucker Band and Boz

Neil Young in concert in Long Beach. *Press-Telegram.*

Scaggs), the Rolling Stones, Led Zeppelin, Leon Russell, Santana, Elvis Presley and the Grateful Dead
- 1973: Traffic, Chicago, David Bowie & the Spiders from Mars, Stephen Stills & Manassas
- 1974: Neil Young, Eric Clapton, George Harrison, ZZ Top, Frank Zappa
- 1975: KISS, Led Zeppelin, Rush, Aerosmith
- 1976: Bachman-Turner Overdrive, Black Sabbath, Willie Nelson
- 1977: Lynyrd Skynyrd, Yes, Blue Oyster Cult, Queen, Kansas
- 1978: Styx, Journey, Van Halen, Ted Nugent, Cheap Trick
- 1979: Elvis Costello & the Attractions, AC/DC, Marvin Gaye

Here's the part where you say, "You forgot about…"

Forgot about what? Talking Heads? Seals and Croft? Dylan? The Eagles' famous break-up concert on July 31, 1980, when Don Felder and Glenn Frey exchanged death threats between each song ("Only three more songs until I kick your ass, pal," Felder reportedly hissed at Frey toward the end of their Long Beach set, with Frey repeating the threat back at Felder during "The Best of My Love")?

So here come the readers with more memories:

"I grew up going to concerts at the Long Beach Arena," recalls reader Barbara Davies, of the Los Altos area of Long Beach. "I don't remember all the concerts I attended, but I do remember my very first concert was Deep Purple. It was festival seating and I thought I would get crushed trying to get in the door."

Davies was one of several readers who recalls the rock scene of twenty or thirty years ago when the arena was regularly packed with fans who came to see some of the best bands in rock history swing through during national tours.

First-time concerts are special affairs, especially in cavernous arenas, such as Long Beach's, where the first show we attended, with eyes as big as 45-rpm platters, nostrils filled with marijuana smoke and eardrums shaking with fear over the thunder to come, was, just like reader Davies's—a Deep Purple show, though the one we attended, in 1971, was headlined by Rod Stewart & the Faces.

In fact, in our excitement, we had arrived so freakishly early (as if the bands would start up quicker the sooner we got there) that we saw the foppish Stewart strutting around in decidedly Britishly garish bell bottoms long before he'd take the stage at about 10:00 p.m.

Rod Stewart in one of his performances in the Long Beach Arena. *Press-Telegram.*

Deep Purple played the arena a few times during the '70s, including shows in 1972 (with Buddy Miles and Uriah Heep opening), 1973 (with Fleetwood Mac and Rory Gallagher on the undercard), 1974 (with the Electric Light Orchestra) and 1975 (with Nazareth).

Even to simply list the rock acts that have appeared in the Long Beach Arena and Auditorium during the '70s would spill out of our regular column and into the Sports section, so today we're just going to go over some of the best shows from '70 to '72, while we await your remembrances of any Long Beach shows throughout the decade.

The biggest acts to come to Long Beach in 1970 were the Doors (February 7); a triple-threat bill of Chicago, Grand Funk Railroad and the James Cotton Blues Band (March 21); the Moody Blues, with Turley Richards, Steve Miller and Poco (April 4); Jethro Tull and Eric Burdon (April 19); Sly & the Family Stone and Mountain (May 9); and Joan Baez (December 18).

Acts drawing crowds in the ten-thousand-plus range in 1971 included the mighty Ten Years After, with Cactus and Humble Pie (May 2); that Faces/Deep Purple show (July 30); a screamer set featuring Black Sabbath, Sweathog and Stoneground (September 25); the return of Joan Baez (October 10); and the biggest show of the year (and one that we snuck into by posing as concession workers by wearing white shirts, black pants and cunning little bow ties), the Who (December 10).

Several emerging acts also visited Long Beach in '71, mostly performing in the small auditorium. That year, drawing fewer than five thousand fans per show, were such acts as Jerry Lee Lewis (January 9); John Lee Hooker with Albert Collins (February 19); John Mayall with Mike Bloomfield (April 8); Alice Cooper with Black Oak Arkansas (July 11); Jeff Beck (October 29); and Arlo Guthrie with Ry Cooder (November 27).

The year 1972 featured the Allman Brothers Band (shortly after the death of lead guitarist Duane Allman) with Alex Taylor opening (March 5); a smart-guy set pairing Emerson, Lake & Palmer with John McLaughlin & the Mahavishnu Orchestra (March 22); Humble Pie with Sweathog (April 16); a classic pairing of the Rolling Stones with Stevie Wonder (June 10); Led Zeppelin (June 27), a hugely attended show (14,014 fans—outdrawing the Stones/Wonder concert by twenty-one tickets and a November 15 concert by Elvis Presley by one ticket); Yes with Edgar Winter and (in the strangest opening-act spot of the year) the Eagles (August 4); Leon Russell (August 28); Humble Pie with Slade and Boz Scaggs (September 4); Santana (October 8); T. Rex with the Doobie Bros. opening (October 15); the King, Elvis Presley, playing a pair of dates (November 14 and 15); and the year closed out with the biggest arena crowd of the year as 14,273 came to see the Grateful Dead in one of its best tours ever, on December 15.

Recalling Restaurants

One glorious summery spring day, while lolling like a manatee in the Hot!House Barn's spa, we were graced with a phone call from the legendary sportswriter (and History Press author) Doug "The Wagon" Krikorian, who, speaking of food (as we will be in a sec), gets something like $750 if you want to have lunch with him—at least that's what some overly wealthy bidder recently paid at auction to have a sandwich with Krikorian.

Anyhow, Dougie wanted to chat for a moment about some of Long Beach's older restaurants, which we were happy to do, since we get all warm and bubbly when it comes to nostalgia, although that could just as easily have been the spa talking.

That chat had us hungrily dwelling on the eateries of our past. Did food really taste better back in the old days (and for our purposes, the old days are the war-torn '60s), or are we being typically sentimental about the glorious past?

No way of knowing, though we were a lot hungrier back in those days, most likely because our mom, bless her little heart, could do a lot of things capably, but cooking—well, let's stick to how good she was at Ping-Pong and typing.

When we were in our formative eating years, our parents would frequently throw money at the problem and let our sister and us trundle off to a couple places that we recall as being the most spectacular dining experiences in epicurean history: Burgermaster, on Palo Verde just north of Stearns Street, and, a bit later, when our family moved a mile to the more prestigious southern section of Long Beach's far east, Annie's Snack Bar, on Palo Verde, just north of Atherton Street.

For fancier fare, our granddad, who threw money around like a Rat Packer, took us to many of the swankier spots in town. He'd get us all dressed up and squire us around to places where a platter of food might go as high as five dollars! Most of his favorite haunts were uptown, around Bixby Knolls: Welch's, at 4401 Atlantic Avenue, was a hot spot, with plenty of Cadillacs packing the parking lot. So was the Chandelier (later Puccini's), 4205 Atlantic, jammed with ladies in mink stoles and everyone tinkling highball glasses in the piano-shaped piano pit. For more exotic fare, he'd point the Buick up Pacific Coast Highway to the Hawaiian, 4645 Pacific Coast Highway.

Other stylish diners around town were the Leilani Hut in the Shore at 5236 Second Street and King Arthur's Steak House, 5511 East Spring Street.

We should note that at all these places, our level of sophistication never wavered from its flat-line preference for hamburgers. That's all we ate anywhere, even if (as we recall it being at the Hawaiian) we had to go off the menu.

We even eschewed pizza and most buffet fare. That's why we were such frequent visitors to the Golden Lantern, 2921 Palo Verde Avenue, where our parents could get a square meal in the Lantern's indoor restaurant, while we got a round hamburger at the outdoor section.

All of our earlier dine-out memories, by necessity, we suppose, center on hamburgers, except for a couple—Uncle John's Pancake House, 3901 East Pacific Coast Highway, and the Hot Dog Show, 754 East Broadway, for, respectively (and obviously), pancakes and hot dogs.

But everything else? Hamburgers: Hody's Los Altos, 5190 Pacific Coast Highway; Oscar's Drive-In, 4525 Pacific Coast Highway (and in Northtown at 6580 Atlantic Avenue); the A&W drive-ins at 3948 Anaheim Street and 5221 Los Coyotes Diagonal; Bob's Big Boy at 2220 Bellflower Boulevard (where we first sampled the most important invention of the twentieth century: the double-decker hamburger); and the sock-hoppy Tic-Toc Drive-In, 4169 Norse Way.

"I don't care how many fancy seafood houses you go to, you'll never find shrimp like they used to serve at the Pike," maintains Myron Hollister, who, like many of our more experienced readers, spent giant chunks of childhood and teenhood at Long Beach's fun zone.

Several other callers/writers testified to the Pike's culinary artistry, with a few people maintaining that all other hamburgers—Russell's, Hof's, whatever—were nothing when slapped side-by-side with a burger from the Pike's Marfleet's Restaurant, which had as its curiously quotation-marked motto: "Always a Good Safe Place to 'Eat.'" But it was the shrimp that

was the seaside Pike's bread-and-butter. The lights along Seaside screamed "SHRIMP" in oxymoronically jumbo-size letters.

Which isn't to say you couldn't get good shrimp up the hill. A couple readers mention Rusty's, in the Wrigley neighborhood at Pacific Avenue and Eagle Street.

"Rusty's had the best and the biggest butterflied shrimp ever," declares Linda Marmion, of the locally world-famous Marmion family, who sold the best peanuts in the world out of their shop in downtown. They eventually sold their roaster to Joe Jost's, which now serves the best peanuts in the world. But back to the past, as Marmion continues, "The fish sticks were delicious and the garlic bread was to die for. When I walked home from Washington Junior High, I would stop for a bag of four pieces of garlic bread (twenty-five cents) and it would be all gone by the time I got home."

Beth Geir throws in with the Rusty's crowd. "They had the most delicious fish and chips," she maintains. "And my sisters and I all agree that the only garlic bread that comes close to Rusty's is the Claim Jumper's."

Moving back downtown, the Apple Valley Steak House was a big hit with readers. Within steps of one another in the area near Alamitos from Broadway to First Street were Vivian Laird's, the Victor Hugo and the Apple Valley. The three places were on a higher order of swank than most restaurants, though the Apple Valley perhaps less so than the others, which only added to its popularity. Recalls a caller, "All night long people would be walking from one restaurant—bar, actually—to another among those three places, but they'd always end up at the Apple Valley."

Many of today's readers' happy memories of Welch's restaurant come from the days when they ordered off the kids' menu. *Press-Telegram archives.*

The Apple Valley Steakhouse, at 733 East Broadway, was a huge favorite along the row of restaurants on Broadway. *Press-Telegram.*

Reverting back to our own experiences, our mention of Pizza-N-Stein on Palo Verde north of Stearns Street elicited some happy memories, including some from an original owner.

"My husband and I located the lot and built the restaurant in the '60s," writes Marilyn Breedlove, noting that they sold it in the '70s to Apple Annie's. Today it's Avenue 3 Pizza.

"The location was ideal, since Long Beach State College, as it was known then, was just down the street," says Breedlove. "We furnished shuttle service to and from Pizza-N-Stein for the students. We had a piano and microphone for those who wanted to perform. Some would bring their guitars."

A reader going by the name of Soupy also recalls Pizza-N-Stein, where our parents would often eat. Alone. They'd send us next door to Burgermaster. "Burgermaster was commonly called Burgermat for short," remarks Soupy. "I don't know if you ever caught his act, but folksinger-guitarist 'Jailbird' Fisher was a regular performer at Pizza-N-Stein. His specialty was R-rated song parodies. Perhaps that's why your parents sent you to Burgermat."

The late Don May's Leilani on Second Street is one of the most frequently cited popular hangouts of the Shore of the '60s—and not just because everyone used to get snockered and reel home after a long night at the bar. In addition to the Leilani's famous (though tragically too short-lived for us to have sampled one) Saketini martini, the place also, according to Shore vet Gerald "Charlie" Brown, turned out some fine Polynesian food.

Brown also chided our readers for their recent booze-themed remembrances of the Trap, on Ocean at Livingston. He says it was more than just a joint to recover from the prior evening's excesses (or to continue them, if you were still going at it at the Trap's 6:00 a.m. opening time). Brown recalls that they had a great cook-your-own-steaks feature there, again, back in the '60s.

That business of doing your own steak-grilling opened our own personal stash of memories of our folks going out and doing that at places like the old Valentine's on Anaheim Street and, we're fairly certain, Poor Richard's, over on Stearns and Palo Verde. It never struck us as a particularly grand idea, going to a restaurant and doing half the work yourself, unless you're one of those if-you-want-something-done-right people. The thrill had gone from the do-it-yourself dining-out experience by the early '70s, when our parents preferred to have us do all the grilling work by visiting us at work when we were cooking, with a young Mark diPiazza, at the Hindquarter Steak House in Naples, where the Naples Rib Co. is now.

Reader Mary Gilroy, now of Darrington, Washington, has her happiest Shore memories at Domenico's, which we don't really count as part of the nostalgic canon because, well, it's still there. Like the lousy country song goes, how can we miss you when you won't go away?

"Domenico's was always the hot spot after Friday Nighters at Rogers Junior High and continued to be the place to go when we moved on to Wilson," she writes.

The Best Sandwich Ever

E-mail from Calista Baldwin made us incredibly hungry for a sandwich that no longer exists and the likes of which we'll probably never eat again.

"What ever happened to Mike's Munchies, the sandwich shop that used to be on Long Beach Boulevard (and other locations)?" she writes. "We used to eat there all the time in the '70s, and I believe into the '80s, and then they all closed."

When we started working in this building in 1976, we'd take our dinner break at the then–newly expanded Mike's Munchies at 1034 Long Beach Boulevard. We'd run a four-block gauntlet of angel-dusters and other colorful street types that stood between us and an avocado-bacon sandwich and a frosty mug of beer. (Contrast those dirt-poor copy-boy days with today, when, in the midst of writing this, we walked down the hall and grabbed a hellishly dry sandwich from a machine and chased it down with some piping hot coffee-flavored boiled water out of a cardboard cup.)

Shop owner Mike Kyle's munchies, packed with extraordinarily fresh products, spices and seasonings, were so good that, despite Mike's Munchies' dicey original location, which opened in May 1971, the shop did a huge business and, in fact, threatened to explode into a nationwide franchise.

A couple years after the first shop opened, Kyle threw in with some investors (including Hubert Hurst of the downtown Long Beach Hubert Cafeterias and Los Altos' famed Golden Lantern Family Restaurant) and opened an ambitious new restaurant in the old (though then-new) Marina Pacifica shopping center.

While the old shop featured some exquisite carpentry, the new place was a woodworker's paradise, with much of the same decidedly hippie feel to it. Hippie, yet swanky, if that's possible (so swanky that the first, and perhaps only, wedding reception booked there was for our wedding). It featured booths hewn from giant barrels, including some elevated ones. Waitresses had to scale ladders to take orders and bring food and beverages.

Without much of a pause, Mike's Munchies began to spring up in other locations, including the Lakewood Center Mall and just off the USC campus.

Everything conspired to ruin Mike's Munchies: overextension in general, the money-sucking Marina Pacifica location, the failed USC site and mismanagement at the Long Beach Boulevard shop. The corporation filed for bankruptcy in 1981, and all the locations closed, save for the original Mike's Munchies, which went through a couple different owners—Mike himself returned as a sandwich-maker for a while—before it, too, finally went under in the late '80s.

Great, but Gone

One of our favorite boomer memories comes from reader Scott McDonnell, who sent a lengthy printout of e-mail exchanges from about a dozen family members recalling their favorite "Lost Places" in town. Among them, Brownie's Toys (in Belmont Shore, Bixby Knolls and Los Altos), Phillip's Chicken Pies (in the Shore and downtown on Pine Avenue), Big John's (the pizza/pool place by the Pier; now Yankee Doodles), Mr. C's and the Hawaiian restaurants, Pierpoint Landing (one of our personal faves, because of the seals you could feed), Naples Market, Iowa Pork Shops in Los Altos, McCoy's Markets all over town, Apple Annie's (now Avenue 3 Pizza) on Palo Verde Avenue, a bunch of head shops whose names nobody could remember (we could go on and on about 1970s-era head shops, but we can't remember their names, either, except ABC Toys on Anaheim Street, three blocks from Wilson High; there was another one across Seventh from Wilson, but its name isn't as easy to remember as ABC) and the slot car–racing place on Anaheim.

McDonnell joined us in recalling the Foremost (in our case) and Adohr (in his) dairies sending photo studio trailers around the neighborhood to take pictures of the kids, which they would print on calendars.

Those days were the darkest days of our youth, when the rigs would pull up and all the kids' moms would haul them in for a Saturday afternoon bath and then get them all dolled up in things made out of scratchy wool so they'd look nice in the calendar that would hang by the kitchen phone for a year. When we tell that to people who have survived the horrors of sub-Saharan Africa, they weep.

Dollar Days was an annual promotion thrown for years by the Long Beach businesses to lure shoppers downtown for old-school bargains. *Press-Telegram.*

Older-timer James Shoemaker declares, "hands down," the greatest loss in the city's history was that of the Spit and Argue Club on Rainbow Pier, where people could soapbox it all day long, ranting about their views and the idiocy of others—in public! Using their real names and showing their faces! Face-to-face bickering—another industry crushed by the Internet.

Rod Barken, who has created a "If you grew up in Long Beach, California, you remember…" page on Facebook, reminds us of Grisinger's Drive-In on San Antonio Drive (now George's '50s Diner), Woodie's Goodies at Alamitos Bay (now Alfredo's) and Kenady's menswear on Second Street, where we used to buy all our cruisewear.

Longtime Long Beacher Doug Volding, who now lives on the wrong side of the Orange Curtain, also throws in with the Pierpoint Landing folks, along with such other water-related landmarks as the pontoon bridge in the harbor, the Plunge at the Pike and the fishing barge off the Belmont Pier. Volding, along with others, also has happy memories of the old Beanie & Cecil's Drive-In at the Traffic Circle.

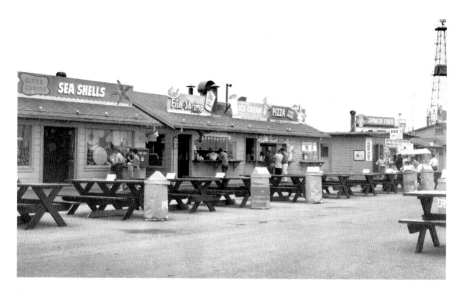

Pierpoint Landing in the Long Beach Harbor was a favorite place to go on weekends for many Long Beachers. *Press-Telegram.*

Cindy Koch recalls a couple memories from Long Beach's rock-and-roll past: the Rumbleseat Garage rock club on the Traffic Circle (about where Staples is now) and KNAC Rock & Rhythm Radio, especially Norm McBride.

Musician, author and our go-to guy on matters of things (musically) we don't understand, Gary Meyers recalls a ton of places he's played over the decades, including George's Roundup on Pacific Coast Highway, the Panama Club on Long Beach Boulevard, the Kopa Room in Bixby Knolls and the venerable Hollywood on the Pike.

Karen and Merlen Kearney came up with more than fifty great places from the past. We've narrowed their list down to Ray & Eddie's Market in Bixby Knolls, Russell's hamburgers in Bixby Knolls and Naples, Desmond's downtown, Newberry's in Belmont Shore, Boulevard Bowl alleys on Long Beach Boulevard near Sixteenth Street, the Book Emporium in Los Altos, the freshly closed Fisherman's Hardware next to Joe Jost's on Anaheim Street, El Patio Restaurant on Atlantic Avenue and the ultra-memorable, if you had to attend it, Call's Dance Studio and Cotillion in Bixby Knolls where, writes Karen, "we learned to dance, feel squirmy about touching the hand of a member of the opposite sex, learn real manners and socialize a lot (shopping, too, for a special party/dance dress at Luan's [Dress Shop in Bixby Knolls]—thankfully still in business)."

RIP, from A to Z

When we asked readers in 2012 to mention the places they miss most about an older version of Big Town, we didn't realize how many beloved places have slipped out of town.

More than one hundred restaurants, stores, bars, buildings and attractions were cited by readers as the best parts of the missing Long Beach. You could build an entire town, practically, out of the submissions from Long Beachers. We're just going to put this together alphabetically:

Acres of Books downtown
Burgermaster hamburger stand in Los Altos
The Crest Theater in Bixby Knolls
Dooley's Hardware in North Long Beach
Egyptian Pharmacy in Belmont Shore
Food Fair in Los Altos
Golden Lantern restaurant in the Plaza/Los Altos
Hamburger Henry's in Belmont Shore
Inner Sanctum Tavern in Belmont Shore
Java Lanes on Pacific Coast Highway
Ken's Restaurant in Bixby Knolls
Los Altos Bakery in the Los Altos Shopping Center
Miss Universe Pageant, held in Long Beach from 1952 to 1959
Northwoods Inn restaurant in Belmont Shore
Oscar's Drive-In restaurant in North Long Beach and at the Traffic Circle

Acres of Books owner Bertrand Smith discusses which books go where with employees in 1959. *Press-Telegram.*

The Pike, downtown on the waterfront
Quigley's department store, in Belmont Shore and the Plaza
Rusty's Restaurant in the Wrigley district
Shady Acres (miniature) Golf Course in North Long Beach
Tracy Theater on the Pike on Seaside Way
Uncle Al's Toy Korral in the Plaza
Valentine's on Anaheim Street
Wanda's Cafe on Sixty-second Place on the peninsula
The X-rated movie houses downtown in the 1970s
The YMCA building downtown
Zody's Department Store in East Long Beach

Now in reverse, except without the X:

Zed Records off the Traffic Circle
The unbreakable YWCA building on Sixth Street downtown
Welch's Restaurant in Bixby Knolls
Virginia Country Market in Los Cerritos
Uncle John's Pancake House on Pacific Coast Highway

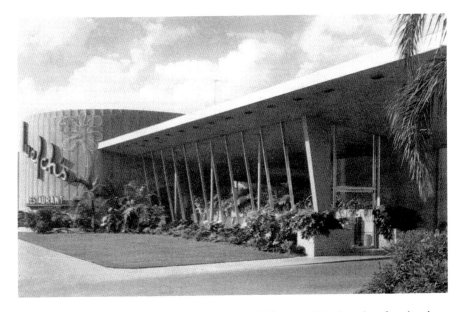

Welch's restaurant at San Antonio Drive and Atlantic Boulevard is a longtime favorite place of the past. *Press-Telegram archives.*

Tastee Freeze on Carson Street
Scotty's Pet Shop in the Plaza
Rainbow Pier downtown
Quickie Chickie in Los Altos
The Plaza Theater in the Plaza
Old Mexico Cafe in the East Village
Nu-Pike, like the Pike, but Nu-er
Mike's Munchies, downtown and Marina Pacifica
Lonnie's Sporting Goods in the Los Altos Shopping Center
Koon's Motorcycles on Anaheim Street
Jolly Roger in the old Seaport Village
Imperial Hardware in downtown
The Hot Dog Show downtown
Green's Hardware (Horace Green & Sons) in the Los Altos Shopping Center
Fiddlers Three restaurants, several locations in Long Beach
Eddie's Bar on Broadway at Redondo Avenue
Drive-in theaters, particularly the Los Altos Drive-in and the Circle Drive-in
The Cyclone Racer at the Pike
The Blue Cafe on downtown's Promenade
Alfred's restaurant in Bixby Knolls

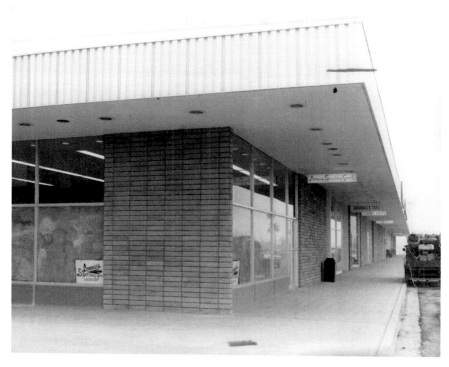

Lonnie's Sporting Goods and other Los Altos Shopping Center stores were just two days from opening in this December 18, 1955 photo. *Press-Telegram.*

And still we've got a lot of leftovers, including some of our favorites, our old Hindquarter restaurant in Naples, Hody's, Curries Ice Cream, Lions Drag Strip, Arnold's Family Restaurant, the Musical Jewel Box, Steak-o-Rama, Bogart's, Kiddie Land, Pierpoint Landing and the Towne Theater.

But is it really a good idea to live in the past? Or should we start building our future, one day to be remembered fondly after that, too, is dismantled?

Maybe later we'll do that. Today we're happier way-backin': Platterpus Records, Licorice Pizza, dangerous park equipment, vacant lots on every block, the Thriftimart lunch counter, the Belmont Theater, Builders Emporium, Plaza Lanes bowling alley, Sad Sack's, the arcades at the Pike...

Acknowledgements

A writer is only as good as his editor. OK, that's a lie. But editing can't hurt. In the midst of some, shall we say, less than glorious editors over my writing years, I appreciate the gems, who include my career-long colleague Rich Archbold as well as Jim Robinson, Carolyn Ruszkiewicz, Bill Lee Shelton, John Futch, Jody Collins and a couple of new kids, Melissa Evans and Ben Demers, who keep making me not want to stop.

For just all-around great encouragement and companionship, I am honored to have as readers and friends Will Shuck, Wendy Thomas Russell, Charles Russell, Thomas Wasper, John Robinson, the Cop Across the Street, Jerry Roberts and, perhaps more than all these people combined, those whose names tragically and unforgivably didn't rise to my consciousness in the few frantic, way-past-deadline moments I took to write this.

And, naturally, nothing I do is done without my love for my wife, Jane, and our children, Ray and Hannah.

Index

INDEX

About the Author

T im Grobaty, a Long Beach native, has been a reporter and columnist for the *Long Beach Press-Telegram* for more than thirty-five years. He has won numerous awards, including Best Columnist in the Western States in the Best in the West journalism competition. He is a recipient of the Long Beach Heritage Award for his columns about the city's history, many of which are included in his previous two books for The History Press, *Long Beach Chronicles* and *Location Filming in Long Beach*. He is an inductee in the Long Beach City College Hall of Fame. Tim lives in Long Beach's far east with his wife, Jane, and children, Raymond and Hannah.